Collins

ROYAL
OBSERVATORY
GREENWICH

D1427031

MOONGAZING

Tom Kerss

Published by Collins
An imprint of HarperCollins Publishers
Westerhill Road
Bishopbriggs
Glasgow G64 2QT
www.harpercollins.co.uk

In association with
Royal Museums Greenwich, the group name for the National Maritime Museum,
Royal Observatory Greenwich, Queen's House and *Cutty Sark*
www.rmg.co.uk

A catalogue record for this book is available from the British Library

ISBN 978-0-00-830500-0

10 9 8 7 6 5 4 3 2

Printed by RR Donnelley APS, China

If you would like to comment on any aspect of this book, please contact us at the above address or online.
e-mail: collinsmaps@harpercollins.co.uk

 facebook.com/CollinsAstronomy
 @CollinsAstro

Contents

Introduction

The Moon is our celestial companion; a source of light; a comfort to many; an icon. It is older than history, and has accompanied our species, hanging silently above, since we emerged from the oceans, where its presence is still felt today. It is the master of the tides – perhaps the key to life itself – and it has inspired stories, poetry, music, and visual artworks of great beauty.

Today we live in an age where the entirety of the Moon's surface has been mapped in astonishing detail from orbit, and human beings have left imprints in its soil. It may seem like there is nothing left to discover there, and yet the Moon keeps calling to us – a hypnotic siren song, urging us to revisit it. Our longing to explore has never been stronger.

Dedicated to Patrick Moore, my mentor and friend. I miss you.
Tom Kerss

A modern amateur telescope – even an inexpensive one – can take you on your own personal voyage to the Moon, where you'll find a timeless landscape whose deep shadows and brilliant highlights are ever changing. Its serene character betrays its true nature as a world of incredible extremes. You can spend a lifetime enjoying these views, and placing yourself there in your mind, just as every great lunar observer before you has, since the invention of the telescope four centuries ago.

It is my hope that this guide will get you better acquainted with the Moon, enabling you to begin making your own observations, and producing your own images. There is no better destination for new space travellers, and the advice ahead will help you take one small step to reach it. Good luck!

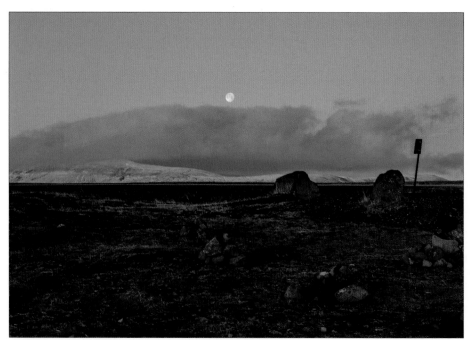

The Moon setting in the morning sky over Icelandic mountains.

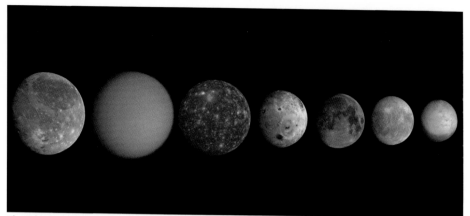

The Solar System's largest moons. Left to right: Ganymede, Titan, Callisto, Io, Moon, Europa, Triton.

The Moon and its Origin

The Moon is another world, our nearest neighbour in space, and due to its close proximity and gravitational bond, a natural satellite of the Earth. To date, it is the only other world to have been visited by human beings, but its familiar face has been pondered since a time long forgotten. It was once considered a mysterious and divine signaller, but our understanding of the Moon advanced suddenly with the development of the space age, which delivered the epic and unprecedented Apollo programme.

The Moon wasn't always the way we see it today. Indeed, it wasn't always there at all. Our unmistakable natural satellite coalesced from a ring of material ejected from the Earth's crust in a catastrophic collision of worlds about four billion years ago. Despite being one of hundreds of moons in the Solar System, it is unusually large for its relatively small parent world. It ranks fifth largest, after Jupiter's Ganymede, Callisto and Io, and Saturn's Titan, with an average diameter of 3,475 km. This makes it just a few hundred kilometres larger than the smallest of Jupiter's four large satellites, Europa.

Due to it having formed much closer to the Earth than it is today, the Moon would have once loomed much larger in our skies, glowing from the intense heat of great seas of lava all over its surface. Over the aeons, it has cooled and solidified, and moved much farther away. This recession continues today, but at such a slow rate – approximately 4 cm per year – that it was all but undetectable until very precise measurements were made in the latter part of the twentieth century.

Like the Earth, the Moon is a differentiated body, meaning its internal structure is layered. Moonquakes have been detected using seismometers on the surface of the Moon, allowing scientists to map its density. It has a small (less than 700 km wide) core of solid and partially molten hot material, likely to be mostly iron, with a maximum temperature around 1,600°C. Above this, the Moon's mantle is partially molten and largely solid, with a crust of igneous material. Despite having cooled long ago, the Moon's surface has been frequently reheated by large impacts, and the violent history of collisions is almost perfectly preserved on its surface today.

It has been shown – using magma samples returned by Apollo astronauts – that at one point in its early history, the Moon had a thin, noxious atmosphere released by volcanic activity on its primordial surface,

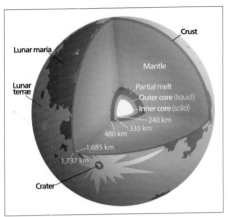

The internal structure of the Moon.

surface travelled surprisingly far when kicked up by the Apollo astronauts.

Large impacts on the Moon have thrown material over hundreds of kilometres across its surface. The 93-km-wide crater Copernicus was formed roughly 800 million years ago, by an object similar in size (a few kilometres across) to the one responsible for the K-T extinction impact on Earth 66 million years ago. Enormous rays of ejected material can be seen stretching away from it in all directions.

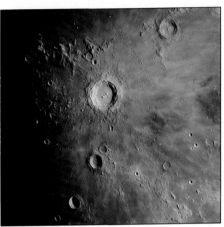

Sunrise in Copernicus Crater. Dramatic ejecta rays are visible stretching away from the crater in all directions. This view comes from one of the Royal Observatory's Victorian telescopes.

but this was stripped away long ago by solar wind. With almost no atmosphere to speak of today, the Moon's surface is not subjected to weather erosion. Impact craters, created by extremely high energy events, have been untouched for hundreds of millions or billions of years, allowing us to look back deep into time by exploring the surface.

Without an atmosphere, the Moon does not distribute heat across its surface, resulting in incredible extremes. The day side has been recorded to reach 120 °C, whereas the night side can plummet to a chilling -170 °C. This enormous variation in temperature presents a unique challenge for both human and robotic explorers.

The Moon's makeup is consistent with the lighter terrestrial material found in the Earth's crust. As such, it has a low density and very low mass for its size. Despite the Moon being just over one quarter the width of the Earth, our planet is about 81 times heavier. We've evolved under terrestrial gravity, and would feel superhuman on the Moon, where the gravitational force felt at the surface is just 16.5 per cent of that on Earth. Everything feels about six times lighter there, and with no atmospheric drag, it is possible to throw things extremely far. Even the powdery regolith on the lunar

The Moon continues to influence us here on Earth, as it has for the entire history of life. Its gentle gravitational tug, not felt by us individually, generates a measurable attraction with the surface water of our planet, creating the tides in our oceans and seas. It is thought that without the tides, there might be no life on our planet at all, and almost certainly no modern land-borne species, including humans. The Moon is the master of the oceans, which collectively form the largest habitat on Earth, and just as we have left a stamp on it, it too has made its mark on us, woven deep into our collective history.

The Waxing Crescent Moon sets from the south coast of England. The Moon is the master of the tides.

The Moon's Orbit and Rotation

The appearance of the Moon in the sky depends on where it is in its orbit. There are many factors to consider regarding the orbit of the Moon. Fortunately, these factors do not greatly affect our view of the Moon, but they are important to understand in order to predict special moongazing events.

Today, the Moon completes one sidereal orbit of the Earth every 27.3 days, which means it reaches the same right ascension in the sky after this period. A common misconception is that the Moon takes 28 days to orbit the Earth, but this has never been the case! Due to the motion of both the Earth and Moon around the Sun, there is a discrepancy between the length of one lunar orbit and the period of time between one New Moon and the next, which is 29.5 days. During this period, known as a lunar synodic month, the familiar phases of the Moon take their turn to appear. We see different amounts of the lit and unlit side of the Moon because the apparent angle between the Moon and Sun changes continuously.

The Moon rotates on its own axis once every 27.3 days, in the same direction (anticlockwise as seen from above the North Pole) as its orbit around the Earth. This results in the misleading illusion that it doesn't appear to rotate at all, as we always see one side from Earth. In fact, the Moon keeps its familiar side facing the Earth throughout its orbit, and the far side is never seen. Only the Apollo astronauts have seen the far side with their own eyes, but robotic orbiters have mapped the entire lunar surface in incredible detail. This synchronised orbit and rotation of the Moon is no accident, but speaks to its ancient relationship with the Earth. The two became tidally locked, carefully curating the Moon's rotation period. Tidal locking occurs elsewhere in the Solar System, for example between Pluto and its large companion Charon.

The distance between the Moon and the Earth also changes, as the Moon's orbit is not perfectly circular, varying between 356,500 km (221,500 miles) at lunar perigee and 406,700 km (252,700 miles) at lunar apogee, if measured between the centres of both bodies. When Full Moon occurs around lunar perigee, it appears slightly larger and somewhat brighter than average – an event colloquially known as a supermoon. These events are not very rare, but perigee and Full Moon do not always align, because lunar perigees are separated by a period of approximately 27.5 days. This is known as an anomalistic month. The difference between this period and a sidereal month means the perigee point of the Moon's orbit undergoes gradual precession, taking nearly nine years to move all the way around the Earth once. This is known as precession of the line of apsides.

Because the Moon's orbit is elliptical, its speed changes as it moves. However, the rotation rate of the Moon remains constant. This discrepancy produces an effect called libration – an apparent 'wobbling' of the Moon – which allows us to see slightly more

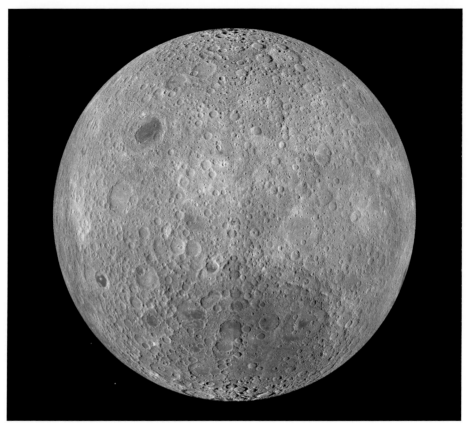

The far side of the Moon captured by NASA's Lunar Reconnaissance Orbiter, heavily cratered but with far fewer maria than the near side. Mare Orientale (Oriental Sea) is shown in the top left.

of its eastern or western sides (known as its limbs) as it moves ahead, or falls behind in its orbit relative to its rotation. Accounting

ecliptic plane (Earth's orbital plane)

Earth

Moon's orbital path 5°

Moon

The Moon's orbital path is tilted approximately five degrees off the path of the plane of the ecliptic.

The Moon's orbit around the Earth.

for both extremes, we can see a total of 59 per cent of the surface of the Moon, but how much we see of the east and west depends on how favourable the libration is with respect to that limb. Because this effect is small, and features on the extreme limbs are less well-known, maps of the Moon in this guide do not show any overall libration bias.

When the Moon crosses the ecliptic, it is said to be crossing a node. The ascending node is the point where the Moon moves northward from the southern celestial hemisphere into the northern celestial hemisphere. The opposite point in the Moon's orbit is called the descending node. Eclipses are possible, and indeed inevitable, only when the Moon is full

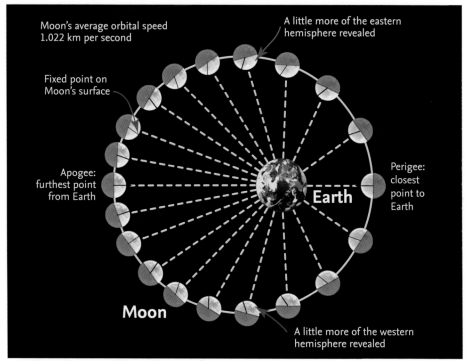

Moon's average orbital speed 1.022 km per second

A little more of the eastern hemisphere revealed

Fixed point on Moon's surface

Apogee: furthest point from Earth

Perigee: closest point to Earth

Earth

Moon

A little more of the western hemisphere revealed

A diagram of lunar libration caused by the elliptical shape of the Moon's orbit.

or new at one of the nodes. When the Moon is not crossing a node, it cannot coincide with the Sun in the sky (a solar eclipse) or the Earth's shadow (a lunar eclipse.)

Lunar Cycle and Phases

The Moon is the second brightest object in the sky after the Sun. Unlike the Sun, it is safe to observe directly without filters. If you own a telescope, the Moon alone can provide a lifetime of mesmerising views, ever changing as the shadows play across its surface. In the observing section, you can find advice on choosing and using a telescope to explore the Moon.

Around New Moon, there is an approximate period of 1.5 days when the Moon is an extremely thin crescent near the Sun and too faint to be seen, even around sunset or sunrise. For the remainder of the Moon's

29.5-day synodic month, the phases are said to wax on to Full Moon and wane off to the next New Moon. The phases are illustrated on page 11 and explained below, with the approximate number of days that separate them. Note that there is no half-moon, as this is not an astronomical term, but rather two quarter-moon phases. The number of days given are averages, and vary slightly due to the Moon's elliptical orbit.

Waxing Crescent: 0–7.4 days. The Moon's eastern limb emerges (east on the Moon is west in the sky). The crescent can first be sighted after sunset, once the Moon and Sun are separated by approximately seven degrees, centre to centre. Only one or two per cent of the Moon as seen from Earth appears to be illuminated at this time, as we are mostly viewing the night side of the Moon. The Waxing Crescent follows the Sun to the western horizon.

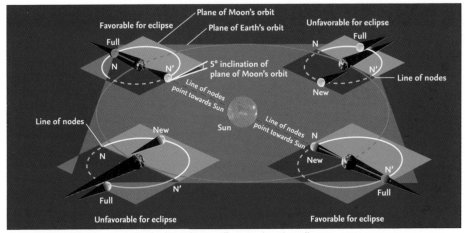

An illustration of the Moon's inclined orbit. Eclipses will occur when the Full or New Moon crosses the ecliptic at the lunar nodes.

First Quarter: 7.4 days. Exactly half of the Moon's near side appears to be illuminated. The terminator, where day meets night, runs vertically along its apparent meridian. Shadows are cast from the east to the west on the Moon at this time.

Waxing Gibbous: 7.4–14.8 days. When illumination is greater than 50 per cent, but less than 100 per cent, the Moon's phase is said to be gibbous. Its western hemisphere is gradually revealed as the Sun begins to rise there.

Full Moon: 14.8 days. At 100 per cent phase illumination, the day side of the Moon is directly pointed at the night side of the Earth and the Moon is full. As the terminator is not visible, there is very little sense of relief on the lunar surface. Full Moon is the only time at which lunar eclipses can occur, when the Moon passes through the shadow of the Earth. The Moon must be close to its ascending or descending node for this to happen.

Waning Gibbous: 14.8–22.2 days. The Moon's terminator emerges on the eastern limb and creeps towards the apparent meridian. Shadows now begin to grow eastward as the incoming sunlight favours the western hemisphere.

Last Quarter: 22.2 days. Only the western hemisphere of the Moon appears to be illuminated. As the Moon is now leading the Sun, it rises in the early morning. The brilliant crater Aristarchus is unmistakable in its dark surroundings near the western limb.

Waning Crescent: 22.2–29.53 days. The terminator moves westward towards the western limb (east in the sky) as the apparent angle between the Moon and Sun decreases. Eventually the Moon appears to become a very thin crescent impossible to see in the Sun's glare. As it rises shortly before sunrise, the waning crescent is the least observed lunar phase.

New Moon: 29.52/0 days. At the moment of New Moon, a new lunar synodic month begins. The New Moon is the night side of the Moon, and too dark to see through the glare of the Sun. New Moon is only directly visible during a solar eclipse.

The location and time of moonrise and moonset depends on your latitude. For the British Isles, detailed information about

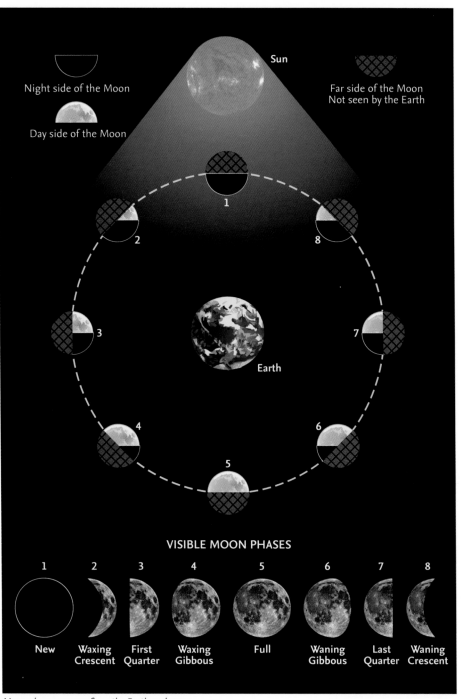

Night side of the Moon

Day side of the Moon

Sun

Far side of the Moon
Not seen by the Earth

1

2

8

3

Earth

7

4

6

5

VISIBLE MOON PHASES

1	2	3	4	5	6	7	8
New	Waxing Crescent	First Quarter	Waxing Gibbous	Full	Waning Gibbous	Last Quarter	Waning Crescent

Moon phases as seen from the Earth and space.

the lunar calendar is available from the UK Hydrographical Office, a department of Her Majesty's Nautical Almanac Office: http://astro.ukho.gov.uk.

More general information can be retrieved from the US Naval Observatory's Astronomical Applications Department: http://aa.usno.navy.mil.

Surface Features

Almost every feature on the surface of the Moon visible from the Earth has been given a name. These names were originally assigned on a somewhat informal basis by early telescopic observers to honour great philosophers and artists of antiquity. As larger telescopes have revealed smaller features, names have been assigned more formally, and the process of cataloguing features is now governed by the International Astronomical Union (IAU.) Craters are named for notable deceased scientists, mathematicians, artists, scholars and explorers. The lunar maria (seas) have older Latin names, which reflect abstract states of mind and weather phenomena considered important to mariners. Lunar montes (mountain ranges) are typically named after terrestrial mountain ranges or nearby craters. Other features, with few exceptions, are named after nearby craters, maria or montes.

Features on the Moon fall into one of several categories. Here each type of feature is described with a typical example shown as viewed through a large telescope.

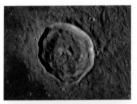

Craters – Fairly circular depressions usually formed from impacts. Occasionally, chains of craters are grouped together and collectively termed catena. Craters feature sloped walls and, on many occasions, central peaks, left over from the crater formation, at which point the lunar surface was locally molten by the energy of the impactor.

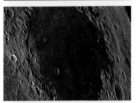

Mare (plural: Maria) – Latin for 'sea'. Large basins of solidified, ancient lava. The maria appear dark relative to the other terrain features. There is one large lunar 'ocean' in the Moon's western hemisphere known as Oceanus Procellarum (Ocean of Storms).

Mons – An individual mountain on the Moon. Lunar mountains were formed by a variety of processes, and vary greatly in size and height. The tallest are approaching 5 km in height, comparable to Vinson Massif, the highest peak in Antarctica.

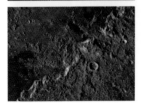

Montes – Large chains of mountain ranges formed by gigantic asteroid impacts billions of years ago. As with terrestrial ranges, prominent individual peaks often have their own names.

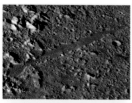

Vallis (Plural: Valles) – A valley or system of valleys formed by lava flows and collapsed lava tubes. These features snake across the surface, often near craters connected to volcanism.

Dorsum (Plural: Dorsa) – Derived from the Latin for the 'back', and connected to ridges or fins on the back of an animal, dorsa are subtle features resembling wrinkles in lunar maria. They are hard to see unless illuminated at a low angle, causing them to cast shadows.

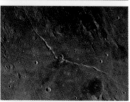

Rima (Plural: Rimae) – Latin for 'fissure'. Rimae, sometimes called Rilles (German for 'grooves') are fissures or cracks in the lunar surface. Not to be confused with valleys, they are often jagged in appearance, with straight sections permeated by kinks. They are seismological features in the Moon's crust, and are sometimes found in crater floors.

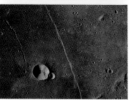

Rupis (Plural: Rupes) – Latin for 'rock', rupes are escarpments in the lunar surface. They appear as large rifts, where a pronounced change in elevation can be seen. In fact, most rupes are very gentle slopes that are many kilometres wide.

Lacus – Derived from the Latin for an opening, a lacus is a lake, which as its name suggests is a very small lunar mare. These features appear as dark, often patchy regions of dark, smooth plains.

Sinus – Derived from the Latin for a gulf, a sinus on the Moon is a bay formed by a rugged 'coastline' of lunar highlands meeting a low elevation, smooth plain such as mare.

Palus (Plural: Paludes) – Though its original Latin name is closer in meaning to a pool, paludes are generally translated as marches. They are low lying, but relatively rugged regions. Whilst they are not as dark as mare, they do have a relatively low albedo when compared with other types of rugged terrain.

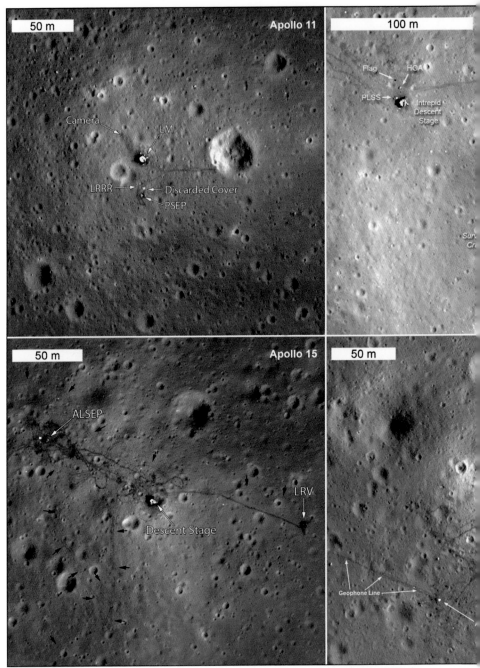

Images of the Apollo landing sites captured by NASA's Lunar Reconnaissance Orbiter from low altitude. The remains of the Lunar Modules and various scientific instrument packages can be seen, as well as tracks left by the astronauts and rovers.

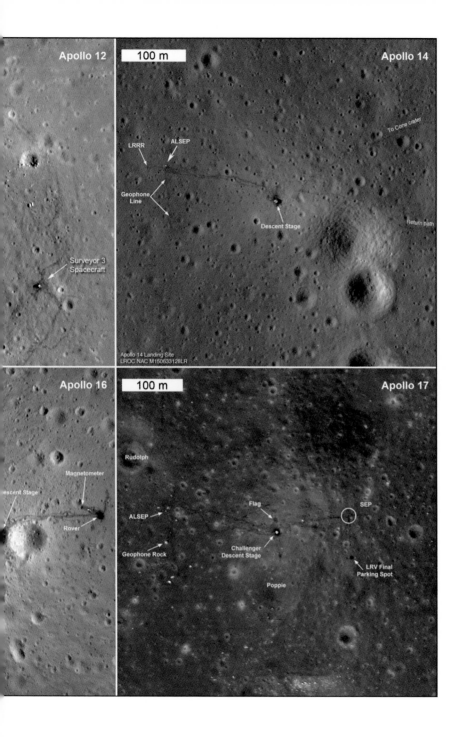

Apollo 12

100 m

Apollo 14

LRRR
ALSEP
Geophone
Line
Surveyor 3
Spacecraft
To Cone crater
Descent Stage
Return path
Apollo 14 Landing Site
LROC NAC M150633128LR

Apollo 16

100 m

Apollo 17

Magnetometer
escent Stage
Rover
Rudolph
ALSEP
Flag
SEP
Geophone Rock
Challenger
Descent Stage
LRV Final
Parking Spot
Popple

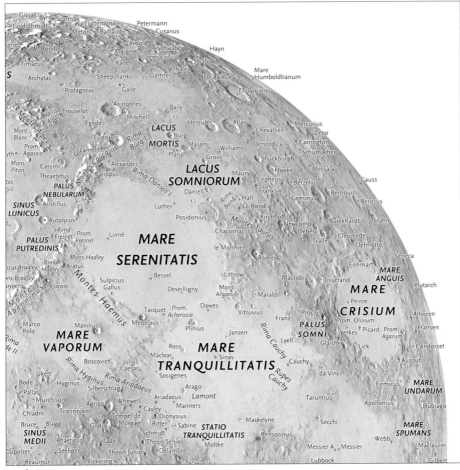

North-East

Due to atmospheric seeing, we are typically limited to observing features no smaller than one arcsecond in apparent size. On the Moon, this corresponds to just over a mile at best. This means that very small objects, such as those left on the Moon by the Apollo astronauts, cannot be resolved through the Earth's atmosphere, but they have been imaged using the Lunar Reconnaissance Orbiter, which was only a few kilometres above the lunar surface.

It's useful to memorise prominent features on the Moon and consider its near side

being divided into four quadrants as shown here. A good knowledge of the locations of the largest lunar maria will help you when choosing areas to explore during your moongazing sessions.

Readers in the southern hemisphere should note that due to the convention of the coordinates on the Moon, it appears upside down in the sky compared with the charts in this guide. From Sydney, the Moon's North Pole appears to be at the bottom. East and west are also reversed. From the northern hemisphere, the Moon's eastern limb is on

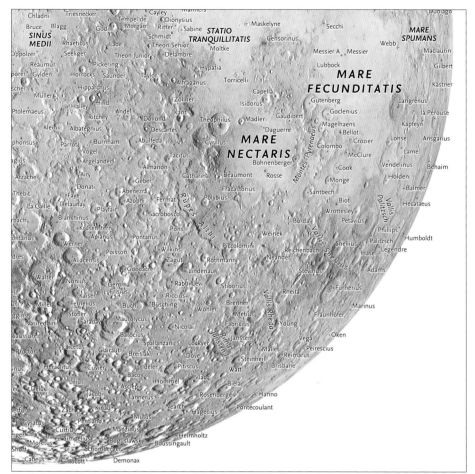

Chladni · Triesnecker · Manners · Cayley · Tempel de · Dionysius · Maskelyne · Secchi · Dubiago
Bruce · Blagg · Godin · Morgan · Ritter · Sabine · **STATIO** · **MARE**
SINUS · Rhaeticus · Lade · Schmidt · **TRANQUILLITATIS** · Censorinus · Webb · **SPUMANS**
MEDII · Theon Senior · Moltke · Maclaurin
Oppolzer · Seeliger · Theon Junior · Delambre · Messier A · Messier · Gilbert
Réaumur · Pickering · Hypatia · Lubbock
pörer · Gylden · Horrocks · Saunder · Taylor · Alfraganus · Torricelli · **MARE**
schel · Hipparchus · Capella · **FECUNDITATIS** · Kästner
Müller · Hind · Zöllner · Isidorus · Gutenberg · Langrenus
Ptolemaeus · Halley · Andel · Kant · Goclenius · la Pérouse
Kleih · Ritchey · Dollond · Theophilus · Mädler · Gaudibert · Magelhaens · Kapteyn
Albategnius · Descartes · Daguerre · Bellot
phonsus · Parrot · Burnham · Abulfeda · Cyrillus · **MARE** · Colombo · Crozier · Lohse · Ansgarius
Vogel · Tacitus · **NECTARIS** · McClure · Lamé
agius · Argelander · Almanon · Bohnenberger · Cook · Vendelinus · Behaim
Arzachel · Airy · Geber · Catharina · Beaumont · Rosse · Monge · Holden
Donati · Abenezra · Flacastorius · Santbech · Balmer
Thebit · Faye · Azophi · Fermat · Polybius · Biot · Hecataeus
La Caille · Delaunay · Playfair · Wrottesley
bach · Blanchinus · Sacrobosco · Borda · Petavius
ontanus · Krusenstern · Pons · Weinek · Phillips
Aplanus · Pontanus · Snellius · Palitzsch · Humboldt
Werner · Piccolomini · Reichenbach · Hase · Legendre
dres · Poisson · Wilkins · Neander
Aliacensis · Zagut · Rothmann · Stevinus · Adams
Goodacre · Lindenau
Walter · Nonius · Gemma · Rabbi Levi · Stiborius · Rheita · Furnerius
Kaiser · Frisius · Riccius · B
us · Miller · Fernelius · Buch · Büsching · Brenner · Marinus
ggins · Stöfler · Wöhler · Metius
Nasireddin · Faraday · Maurolycus · Nicolai · Fabricius · Young · Fraunhofer
Saussure · Barocius · Janssen · Oken
Spallanzani · Lockyer · Vega
Proctor · Licetus · Clairaut · Breislak · Dove · Mallet · Peirescius
Heraclitus · Cuvier · Ideler · Pitiscus · Steinheil · Reimarus
inus · Baco · Watt · Brisbane
Lilius · Asclepi · Hommel · Vlacq
er · Delue · Jacobi · Biela
erfurd · Zach · Kinau · Nearch · Rosenberger · Hanno
Cysatus · Pentland · Mutus · Hagecius · Pontécoulant
rger · Curtius · Manzinus
Moretus · Simpelius · Boguslawsky · Helmholtz
Short · Schomberger · Boussingault
Cabeus · Scott · Demonax

Montes Pyrenaeus · Rupes Altai · Vallis Palitzsch · Vallis Snellius · Vallis Rheita · Rima Janssen · Vallis Rheita

South-East

the right; from the southern hemisphere, it is on the left.

North-East

The north-eastern quadrant of the Moon is dominated by the dark Mare Serenitatis (Sea of Serenity), landing site of Apollo 17, and Mare Tranquillitatis (Sea of Tranquility) where Neil Armstrong and Buzz Aldrin became the first humans to step foot on the lunar surface during the Apollo 11 mission. Mare Crisium (Sea of Crises) lies near the eastern limb, and south of it Mare Fecunditatis (Sea of Fertility).

South-East

The south-eastern quadrant of the Moon is remarkable for having no maria, save for the southern region of Mare Nectaris (Sea of Nectar). It's mostly composed of rugged highlands, pockmarked with high energy impacts ranging right across the history of the Moon. The prominent Tycho Crater is found in this region, with its bright rays of ejecta visible over 1,600 km (1,000 miles) from the impact site. Astronauts on the Apollo 16 mission collected material from these rays to be analysed on Earth.

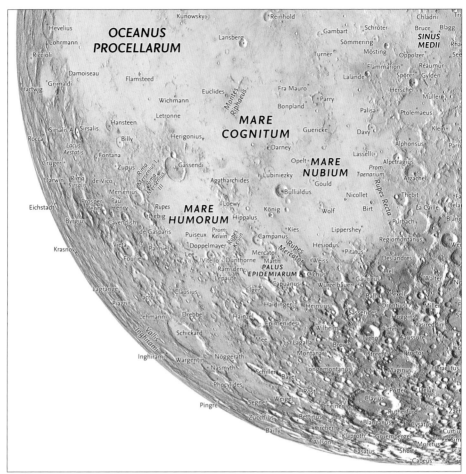

South-West

South-West

The south-western quadrant of the Moon features several small maria and a portion of the giant Oceanus Procellarum (Ocean of Storms) as well as the landing sites of Apollo 12 and 14. Near the western limb, the dark crater Grimaldi can be seen, having the appearance of a small lunar sea in its own right. Byrgius crater, a popular sight, is to the south of Grimaldi.

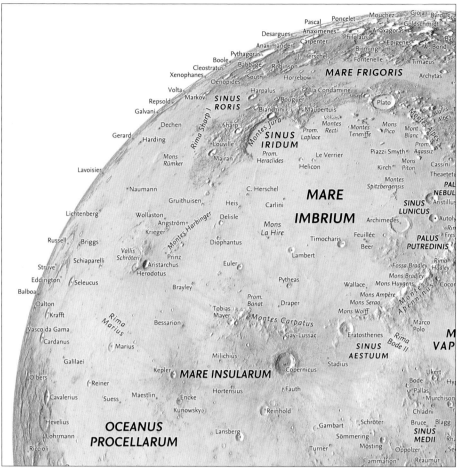

North-West

North-West

The north-western quadrant of the Moon is home to prominent craters such as Kepler, Copernicus and Plato, as well as Aristarchus, the brightest crater on the entire surface. The bright craters and dark plains of Oceanus Procellarum and Mare Imbrium (Sea of Showers) make this one of the most striking, high-contrast regions of the Moon. Nestled in the western edge of Mare Imbrium is Sinus Iridum (Bay of Rainbows.)

History of Lunar Observation

The Moon has lingered in our skies as long as life has existed on Earth. It predates the earliest murmurings of consciousness by billions of years. When our ancestors began to take notice of the objects in the sky, the Moon was already a familiar sight, whose regular visits were probably a source of comfort, providing a source of natural light at night. But as the earliest humans attempted to explain the world around them, events in the sky became steeped in superstition. Then unpredictable, aberrant changes in the appearance of the Moon, such as eclipses, terrified ancient people as harbingers of doom. Today we flock to see them and enjoy the spectacle.

Eventually this perception of the Moon as a god of many moods began to fade, when as early as the fifth century BCE, astronomers in ancient Babylon learned to predict its eclipse cycle through careful record-keeping across generations. Meanwhile, in Asia, astronomers in what is now modern-day India worked out how to describe the apparent elongation between the Moon and Sun throughout the full synodic month.

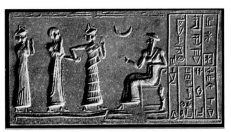

The Mesopotamian god of the Moon, Sin, depicted on a tablet at the British Museum.

A great deal of progress was made when mathematical cosmologies – descriptions of what we now call the Solar System, but what was once considered to be the centre of the Universe – were developed in ancient Greece. Notably, Aristarchus in the second century BCE, considering the Moon as a spherical ball of earth or rock, computed its size and distance. His results weren't precise, but they were certainly better than anything that had been achieved before. In the same century, Seleucus had correctly linked the Moon to the tides, long before Newton would describe the force responsible.

A few hundred years later, Ptolemy significantly improved on previous calculations about the size and distance of the Moon, but with the transition to the Middle Ages, this progress of understanding slowed down.

The next leap in lunar observation would occur with the invention of the telescope in the early seventeenth century. Skilled observers of the pre-telescopic era, such as Tycho Brahe, had attempted to discern the Moon's surface, but even the best of their visual acuity was no match for the telescope. Many people incorrectly believe that Galileo Galilei pioneered the use of the telescope in astronomy, but he was actually beaten to it by Thomas Harriot, an English scientist then living in London. Harriot was credited with making the first sketch of the Moon with the aid of a telescope in July 1609, approximately four months before Galileo's first use of such an instrument. Nevertheless, Galileo was the first to make a systematic study of the sky using the telescope, and in the following year published his ground-breaking Sidereus Nuncius (Starry Messenger), including sketches of the Moon, showing unprecedented detail.

Over the next 400 years, rapid improvements in telescope technology would greatly improve our perception of the lunar surface. Generations of skilled observers discovered and catalogued features large and small, attempting to explain their origin. The Moon became the subject of the very first successful astronomical photograph, which was a daguerreotype captured by John Draper in 1840.

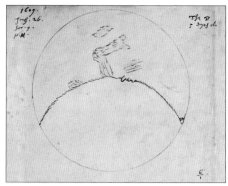

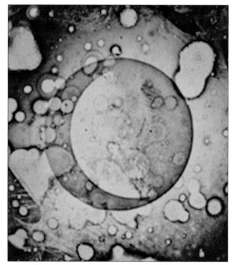

Top: Thomas Harriot's sketch of the Moon, believed to be the first observation made with a telescope, on 26 July 1609, from London. It shows features on a five-day-old waxing crescent.

Bottom: Galileo's early lunar sketches, published in Sidereus Nincius (Starry Messenger) showing details in the terrain along the lunar terminator.

John Draper's Daguerreotype of the Moon.

A century later, humanity was on the cusp of a new age – the space age. With space exploration in sight, the Moon would become a subject beyond mere observation, but rather a place of exploration.

History of Lunar Exploration

On 4 August 1957, the Soviet Union launched Sputnik 1, the first artificial satellite of the Earth. During a 21-day mission, Sputnik 1 demonstrated that space was within reach. Energised by their success, the Soviet Union would break new ground with the success of the Luna programme, when Luna 1 became the first spacecraft to reach the Moon. On 2 January 1959, Luna 1 was launched on board the newly designed Luna 8K72 rocket, breaking the Earth's gravitational escape velocity and reaching the Moon in under three days. Unfortunately it failed to impact the Moon as was planned due to an error, and instead missed it by 6,000 kilometres.

Later that year, Luna 2 did successfully impact the Moon on 13 September, crashing into the east of Mare Imbrium (Sea of Showers). Its follow-up mission, Luna 3,

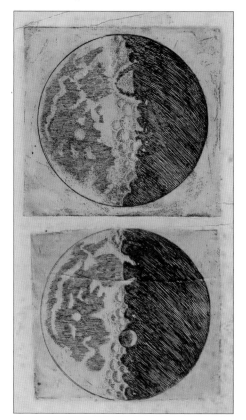

returned close-up photographs of the Moon, including the first ever view of its far side, never seen from Earth.

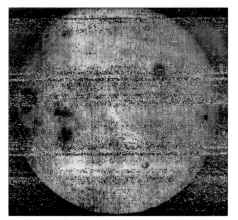

The far side of the Moon, as seen by Luna 3 in 1959. This is the first image ever returned of the Moon's previously unseen far side.

The Luna programme would make yet more breakthroughs. Luna 9 made the first successful soft landing on the Moon on 3 February 1966, and Luna 10 became the first artificial object to orbit the Moon less than two months later. The United States had already responded, with NASA developing its own spacecraft platforms called Pioneer and Ranger. After many unsuccessful attempts, Ranger 7 was the first American probe to

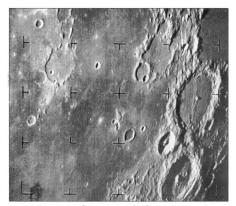

Ranger 7 image of the Moon, the first taken by a US spacecraft.

transmit photographs of the lunar surface in July 1964. Along with its siblings Rangers 8 and 9, it returned thousands of photographs before impacting the lunar surface.

Then, just three short years later, NASA would unveil its plan to fulfil a promise to put human beings on the Moon by the end of the decade. In the summer of 1967, NASA was preparing to use the largest and most powerful rocket ever created, the Saturn V. After years of development, testing would begin with the first launch on 4 November that year. The following year, on the winter solstice, NASA made immortal history with the launch of Apollo 8, which would take three astronauts beyond Earth orbit for the first time, sending them for a round trip to the Moon and back. On Christmas Eve 1968, Lunar Module Pilot William Anders captured the Earth rising from the Moon's horizon, one of the most famous photographs in history.

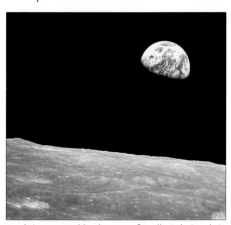

Earthrise captured by the crew of Apollo 8 during their orbit of the Moon in December 1968.

In May 1969, Apollo 10 repeated the practise run, and three astronauts travelled to the Moon and back. NASA was now ready to attempt a landing. The date for Apollo 11 was set for July, and on the 16th, Commander Neil Armstrong, Command Module Pilot Michael Collins and Lunar Module Pilot

Edwin "Buzz" Aldrin departed Earth. On the 20th, having entered lunar orbit a day earlier, Armstrong and Aldrin touched down in the southern region of Mare Tranquillitatis (Sea of Tranquility) at a site since known as Tranquility Base, whilst Collins remained in orbit on board the Command Module. Armstrong would be first to step out of the Lunar Module, where he was greeted by a barren expanse of rolling hills, littered with rocks and coated by a fine powdery material called regolith. His colleague Aldrin would famously describe the site as one of 'magnificent desolation'.

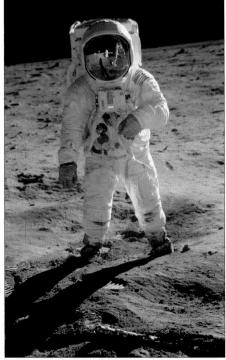

Buzz Aldrin on the Moon. Neil Armstrong, the photographer, is visible in the reflection on Aldrin's visor.

Armstrong's famous first words on the Moon, 'that's one small step for a man, one giant leap for mankind' were broadcast live (accepting the delay of over one second from the Earth to the Moon) to millions of viewers worldwide, inspiring generations. The efforts of hundreds of thousands of people working on the Apollo programme were hailed as a huge success, and the Apollo 11 astronauts returned safely home to become heroes.

Neil Armstrong takes the famous first step onto the lunar surface, broadcast live around the world in July 1969.

In November, Apollo 12 followed the success of the mission, with another crew of three including Lunar Module Pilot Alan Bean. Alan would return to Earth and become a prolific artist, presenting the lunar surface as he saw it with his eyes. He had wished the author well with the writing of this book shortly before he passed away, aged 86, on 26 May 2018.

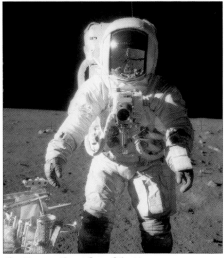

Alan Bean on the surface of the Moon during Apollo 12 in 1969.

With the coming of the new decade, in 1970 the Luna 16 mission became the first robotic probe to return a sample of moonrock to the Earth. On 24 September, 101 grams of soil from Mare Fecunditatis (Sea of Fertility) touched down by parachute in Kazakhstan. Less than two months later, Lunokhod 1, travelling aboard the Luna 17 spacecraft, became the first rover operated on the surface of the Moon after touching down in Mare Imbrium (Sea of Showers) on 17 November 1970. It was solar powered, capable of keeping itself warm at night, and would operate for nearly eleven lunar days (ten months) instead of the planned three. Lunokhod 1 represents an important step in the history of exploring the Solar System. It was a true remote robotic laboratory, operating on the surface of another world with the freedom to explore, and travelled 10.54 km over its operational lifetime.

as the Lunar Roving Vehicle. This enabled astronauts on the surface to survey several kilometres around their landing sites. During these missions, many experiments and surveys were carried out, and a collective 382 kilograms of samples were returned to Earth, resulting in an enormous leap forward in our understanding the Moon. On 14 December 1972, Commander Eugene Cernan stepped back into the Apollo 17

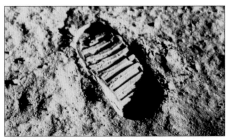

A footprint left on the Moon by an Apollo astronaut. These markings will remain on the lunar surface for billions of years.

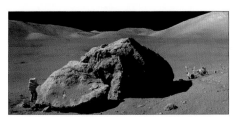

Gene Cernan inspects a large rock, possibly ejected from an ancient impact, during the Apollo 17 mission in December 1972.

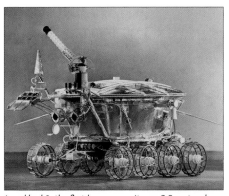

Lunokhod 1, the first lunar rover. It was 2.3 metres long.

The Apollo programme also continued. The ill-fated Apollo 13 mission, commanded by Jim Lovell (who had previously flown as Command Module Pilot on Apollo 8) was struck by catastrophe on the way to the Moon, when one of its oxygen tanks exploded. Despite facing enormous challenges, all three astronauts arrived home safely – aborting any attempt at a landing and swinging around the Moon. Apollo 14, 15, 16 and 17 continued, with the last three missions carrying an electric buggy known

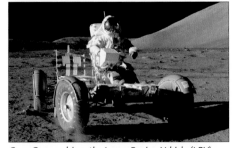

Gene Cernan drives the Lunar Roving Vehicle (LRV), a lightweight electric rover with a top speed of about 18 km (11 miles) per hour. The Apollo 17 crew totalled about 35.4 km (22 miles) distance covered.

Lunar Module, leaving the very last footprint on the Moon. Nobody has returned since.

Since the dawn of spaceflight, many successful Moon landings have been made, and many more are planned. Whilst lunar landings have been rare in recent years, and no manned mission has been attempted since 1972, reduction in the cost of spacecraft development and launches will drive us forward to explore more of the Moon's surface in the coming decades. Meanwhile, lunar science continues with orbiting missions, which have mapped the Moon's surface in extraordinary detail, surveyed its chemical composition, and even probed its internal structure. The European Space Agency (ESA) and the Japanese Aerospace Exploration Agency (JAXA) have both sent orbiters to the Moon in the 21st century, and the Chinese Chang'e 3 placed a rover on the surface in 2013.

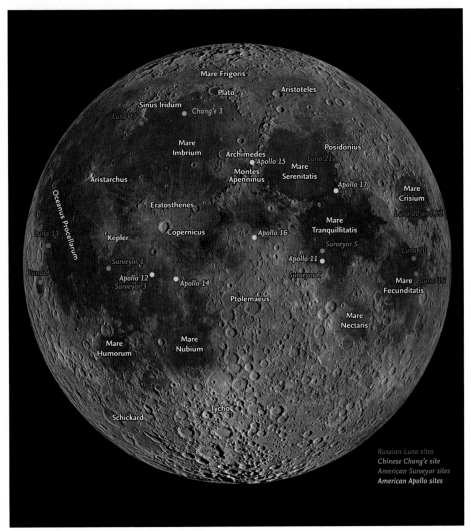

Russian, US and Chinese landing sites on the Moon.

Eventually humans will return to the surface of the Moon, picking up the unfinished business of the Apollo astronauts, and establishing a permanent presence there. The Moon will one day become humanity's outpost in space – a place for us to practise living on another world as we dream of Mars. Perhaps young readers of this book will one day visit the Moon, to work there or as a tourist! It seems far away, but with so much renewed interest in the Moon, it may happen sooner than you think. For the time being, you can get familiar with the Moon from the comfort of your own planet.

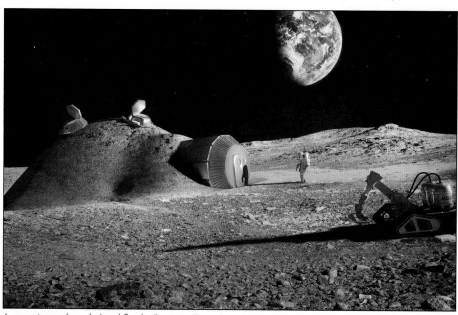

A concept moonbase designed for the European Space Agency.

Observing the Moon

The Moon's orbit around the Earth takes it through the zodiacal constellations once every 29.5 days. It is trivial to identify, but because there are periods of the lunar month when the Moon is not visible, or does not rise until the following morning, you should plan your observing sessions by checking the moonrise and moonset times. Of course it is also possible to see the Moon during the day for much of the lunar month, and whilst its contrast will be lower when looking through a blue, sunlit sky, its features can still be discerned and explored.

The Moon's largest features can be seen with the naked eye alone, as can its very brightest craters. With binoculars, many more features can be seen. Modern binoculars easily outperform the earliest instruments used by Thomas Harriot in 1609 when he made the first recorded telescopic observations of the Moon.

You may have noticed that when the Moon is low in the sky it looks very large to the unaided eye. When the Moon is higher it seems smaller – this strange effect is an illusion created by your brain. In fact, the Moon maintains virtually the same angular size at all altitudes over the course of the night or day.

When the Moon is low in the sky, your brain compares it to the surrounding landscape.

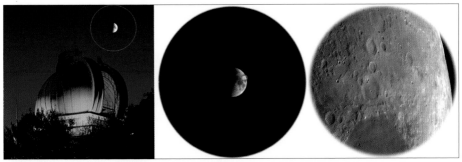

The Moon as seen by the eye, binoculars and a telescope.

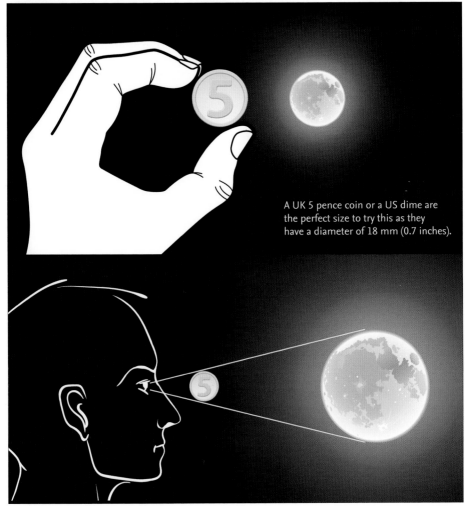

A UK 5 pence coin or a US dime are the perfect size to try this as they have a diameter of 18 mm (0.7 inches).

The apparent size of the Moon in the sky.

Relative to the buildings and trees around us, the Moon looks bigger than usual. When you see the Moon high in the sky, the landscape is out of your field of view, so it looks smaller. You can break through this illusion by holding out a five pence coin (or something else of the same diameter) at arm's length and use it to cover the Moon at both low altitude and high altitudes – you'll see there's no appreciable difference in its size.

If you already own a pair of binoculars suitable for birdwatching or stargazing, they will make an excellent starting point before investing in a telescope. Nevertheless, detailed observations and high-resolution lunar photography will require a telescope, and because the telescope market is always progressing, it's wise to set a budget and speak to an astronomy dealer for advice.

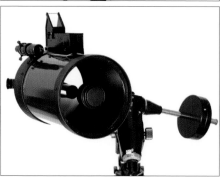

Top: A reflecting telescope where the light-gathering component is a mirror.
Bottom: A Schmidt-Cassegrain telescope, this is a catadioptric telescope.

Choosing a telescope

A telescope is a remarkable piece of technology. With as few as two pieces of glass, it is possible to bring another world into sharp view, and even the amateur telescopes available to buy today are outstanding for lunar observation. Telescopes are available in several designs.

Refractor: The oldest and most robust type of telescope, it uses lenses at the front of a tube to bring light to a focus at the back. Refractors produce an image that is inverted and back to front, however a corrector called a star diagonal can be used to produce upright images. Refractors offer high contrast views with rich colour and contrast, but because lenses are expensive to manufacture, they tend to have smaller apertures.

Reflector: Many larger telescopes employ mirrors to bring light to a focus. The most popular amateur design available, the Newtonian Reflector, has two mirrors, bringing the image to focus near the front of the tube on one side. For an equivalent cost, reflector telescopes are larger than refractors, showing greater detail, but they do often need to be collimated, and are less robust. The images produced by these telescopes are flipped.

Catadioptric: A catadioptric or compound telescope, such as a Maksutov-Cassegrain

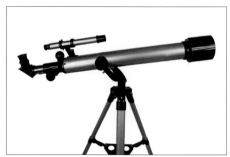

Refracting telescope (the light-gathering component is a lens). The image is seen from the back of the telescope.

or Schmidt-Cassegrain, is made using both mirrors and lenses, and produces an image like a refractor, focused at the back of the telescope. These designs are robust and can produce very good contrast. They are also very compact for their effective resolving power, but are generally expensive.

When viewing the Moon, almost any telescope will give you an acceptable image, but it's advisable to invest in a good, well made and stable instrument, which is simple to set up. The best telescope is the one you use the most, not necessarily the largest. Ensure you're comfortable with setting up and packing down a telescope, so its complexity doesn't become an obstruction to your moongazing.

Many telescopes include computerised software called GoTo systems. When properly aligned, computerised telescopes offer very precise tracking, and many support tracking at the lunar rate. Because the Moon is orbiting the Earth, it moves eastward approximately one apparent lunar diameter per hour. This drift backwards against the motion of the stars must be compensated for to achieve perfect tracking. Tracking is particularly useful for high-resolution imaging of the lunar surface.

Eyepieces and Filters

An eyepiece is used in all telescopes to capture a small part of the centre of the image and blow it up in size before it is projected into your eye. Generally speaking, a telescope should not be used at a magnification that is greater than twice its own aperture in millimetres. For example, a 130-mm aperture telescope should not exceed 260x magnification. A greater magnification would produce a fainter image with no extra detail. You can calculate the magnification you'll get by dividing the focal length of the telescope by the focal length of the eyepiece. For example, a telescope with a focal length

of 1,500 mm combined with an eyepiece of focal length 25 mm will produce an effective magnification of 60x. Barlow lenses are an inexpensive way of doubling your eyepiece collection, usually offering a 2x or 3x amplification factor.

Because the Moon subtends less than one degree in the sky, it can be seen in its entirety at low powers. Many telescopes are packaged with two eyepieces, one of which will give a lower power and wider field of view than the other. This is the best eyepiece to use first, as it will be easier to find and centre the Moon's image when you can see more of the sky, before swapping it for a higher mangnification.

For higher magnifications, eye-relief (the distance between the eyepiece lens and the surface of the eye) can become uncomfortably tight, but there are long eye-relief designs available. It's worth investing in a comfortable high-power eyepiece for your telescope, to achieve powers of 100–200x or more. It is at the highest magnifications, during moments of very steady seeing, that you will see the most intricate visible details on the Moon.

On most nights, the practical limit of magnification is imposed by the transparency and steadiness of the atmosphere to around 250x. Exceptional nights will allow you to exceed 300x, but even on an average night a great number of details can be seen, such as craterlets inside larger craters, rilles and dorsa.

Modern eyepieces feature a thread inside the barrel designed to hold a filter. For moongazing, it's not uncommon to use a moon filter. This is a neutral density filter, designed to dim the image and prevent eye strain from looking at such a bright object in a telescope. Whilst there is no risk to observing the surface of the Moon, even if it appears very bright, a moon filter can make your session more comfortable. A variable

polarising filter can be adjusted in strength, allowing more flexibility for use on different lunar phases.

Colour filters are available for planetary observation, and are identified by a number and label. For viewing the Moon, there is one filter widely regarded as the best – the no. 21 orange filter. With this inexpensive filter attached to your eyepiece, you can see the Moon's features revealed with much greater contrast, albeit looking very orange! This is particularly useful when lunar shadows are hard to discern, or to find relatively subtle paludes in the lunar maria. This is an excellent addition for the advanced moongazer!

Sketching

The long-standing traditional method for recording observations of the Moon is to sketch what you see. This is a rewarding

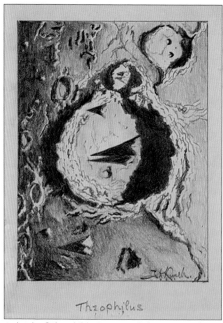

A sketch of Theophilus Crater made by Dr Samuel Russell in the early twentieth century, using a home-made telescope.

activity that will help improve your visual acuity. You can photocopy the observation charts at the back of this book and sketch your field of view. Remember to note the equipment you used, the time and date of the observation and the sky conditions. The longer you study a particular part of the Moon, the more detail you will notice. As the seeing continuously changes, for brief moments you will see smaller features appear. Give yourself plenty of time to modify your sketch and add these details as you notice them – a good lunar sketch can take an hour or two to complete!

Special Events

There are many transient events occurring on or around the Moon, which you will need to plan carefully to see. These events are rewarding to catch, but not all of them are as spectacular as they sound. The annual Collins *Guide to the Night Sky* highlights these events, with the dates and times that they occur, and how best to see them.

Eclipses

As we have seen, the Moon's orbit is inclined, producing two nodes which, when crossed during New Moon or Full Moon, allow eclipses to occur. When the Moon comes between the Earth and the Sun, a solar eclipse occurs. The New Moon partially or totally covers the face of the Sun – a partial or total solar eclipse, respectively. Due to the changing distance between the Earth and the Moon, if a total eclipse occurs at or near lunar apogee (the maximum distance) a rare annular eclipse can be seen.

As the Moon's shadow slinks across the Earth's surface, observers underneath it will observe the eclipse, and the degree of coverage will depend on where they are. These eclipses are relatively rare, as the alignment of the Sun and Moon must be very precise.

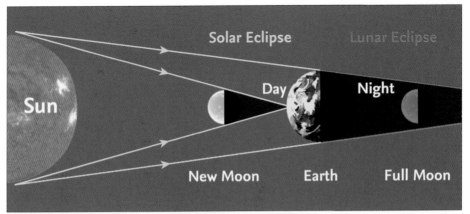

Positions of the Sun, Earth and Moon during a solar and a lunar eclipse.

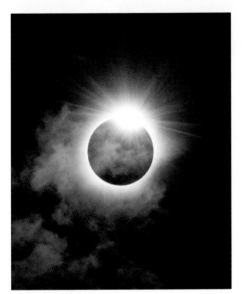

Total solar eclipse.

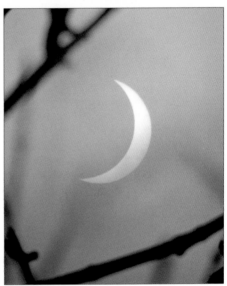

Partial solar eclipse.

Please note that while it's tempting to think the Sun becomes safe to view when covered by the Moon, it is always dangerous to view the Sun without filters. Even during an eclipse, the brilliance of a portion of the Sun can cause permanent eye damage!

When the Moon passes through the Earth's shadow, a lunar eclipse occurs. These are more common and longer lasting, because at the distance to the Moon, the Earth's shadow is about 2.5 lunar diameters across. Partial lunar eclipses are the most common, and total lunar eclipses less so. During a total lunar eclipse, the Moon passes through the deepest and darkest part of the Earth's shadow. Curiously, the shadow is not black, but a deep red colour, resulting in the 'blood moon' effect. The red light is sunlight scattered through the Earth's atmosphere and into its shadow.

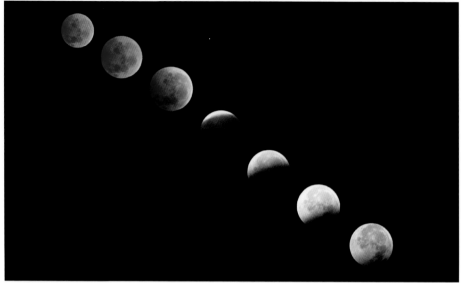
Stages of a total lunar eclipse.

An astronaut standing on the Moon during a total lunar eclipse would see the ground around them descend to a dark ashen colour. Meanwhile in the sky above, they would see the night side of the Earth surrounded by a red ring – every sunrise and sunset on our home planet seen simultaneously! Because the Earth's atmosphere is scattering light onto the Moon, a very precise high-colour photograph of the Moon during a total lunar eclipse shows layers of our atmosphere in subtly different colours

Conjunctions and Occultations

Because the Moon travels close to the ecliptic path on its orbit, it will frequently pass the much slower moving planets through the sky. When the Moon and a planet appear close together in the sky, they are said to be in conjunction. These events are beautiful to admire and offer lovely photo opportunities. Much less common is a conjunction so close, that an occultation occurs. This happens when the Moon passes right in front of a planet (or a very bright star) covering it up. Eventually, the Moon will pass by and the planet or star

re-emerges on the lunar limb. Occultations remind us that the Solar System is constantly in motion, like a colossal clockwork device. Conjunctions can be spread over two or three nights, but occultations are timed to the second. Refer to the Collins *Guide to the Night Sky* for advice on when to see these events in the sky.

Supermoon

When a Full Moon coincides with lunar perigee (the closest approach of the Moon to the Earth in its orbit) it is often called a supermoon. This is not a scientific term, but rather a colloquialism. A Full Moon occurring at lunar apogee is sometimes called a 'minimoon'. The difference in apparent size between an apogee Full Moon and perigee Full Moon is 14 per cent of the Moon's diameter. This results in a maximum difference in brightness of 30 per cent. This may sound significant, but in reality these events are not as super as their name suggests. Apogee and perigee Full Moons do not precede each other, so a direct comparison is impossible, and whilst the difference is measurable with

a precise instrument, it is almost impossible to see with the unaided eye. Nevertheless, the popularity of the supermoon does inspire us to do more moongazing.

Blue Moon

The term blue moon is very misleading, because these events have no effect on the

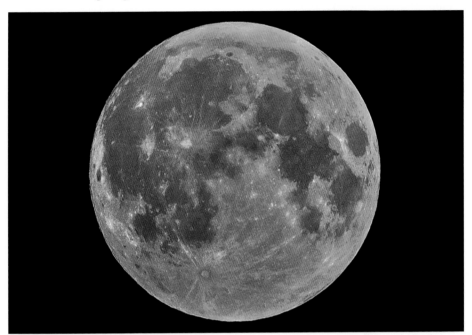

A total lunar eclipse seen in enhanced colour, revealing banding in the Earth's atmosphere. The violet band is produced by ozone absorption in the stratosphere.

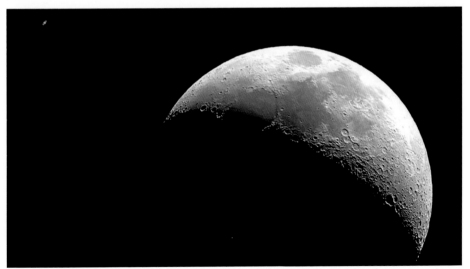

Saturn in conjunction with the Waxing Crescent Moon. Saturn's rings are visible, encircling the planet.

apparent or real colour of the Moon. Whilst its meaning has changed since the inception of the term, a blue moon is generally taken to be the second Full Moon in a calendar month. The lunar synodic month is 29.5 days long, but eleven calendar months are longer than this. February is the only month where blue moons are impossible. During any other month, if the Full Moon falls very close to the beginning of the month, the next one will squeeze in at the end. Blue moons are not very rare, occurring once every 2.7 years on average, but they serve as a reminder that our calendar is arbitrary and not connected to the precise natural cycles of the Moon.

A comparison of the smallest and largest apparent size of the Full Moon, a 'minimoon' and 'supermoon', respectively. The difference is virtually imperceptible to the unaided eye.

Calendar Month	Traditional Full Moon Name
January	Wolf Moon
February	Snow Moon
March	Worm Moon
April	Egg Moon or Pink Moon
May	Flower Moon
June	Strawberry Moon
July	Hay Moon or Buck Moon
August	Barley Moon or Sturgeon Moon
September	Harvest Moon
October	Hunter's Moon
November	Beaver Moon
December	Cold Moon

Full Moon traditional names

Introduction to the Lunar Atlas

The following pages contain detailed charts and photographic reconstructions of the lunar surface, subdivided into sixteen sections. Many interesting features are labelled, and the corresponding photorealistic images allow you to see how the features actually appear through a telescope at high magnification under good atmospheric seeing conditions.

It is important to note that as the phases of the Moon progress, and the illumination angle of sunlight reaching the surface changes, features continuously take on new and unique identities. In this atlas, the apparent telescopic views are all presented with an identical illumination angle, such that the shadows give a sense of relief to the Moon's rugged surface. At Full Moon, these shadows disappear, and so too does the apparent contrast of the surface features. At this time, the Moon appears relatively 'flat'. Looking at or near the terminator – where day meets night on the Moon – as the phases progress will give you the strongest impression of height and depth.

For each chart, a brief description of notable features is given. These are excellent landmarks for a beginner, and will help to familiarise you with the variety of interesting sights to discover as your observing skills become more advanced.

On these charts, craters are identified simply by their names, whereas other features are identified by their type and name.

Progression of lunar shadows, from left to right: morning, midday and afternoon.

MAP 1

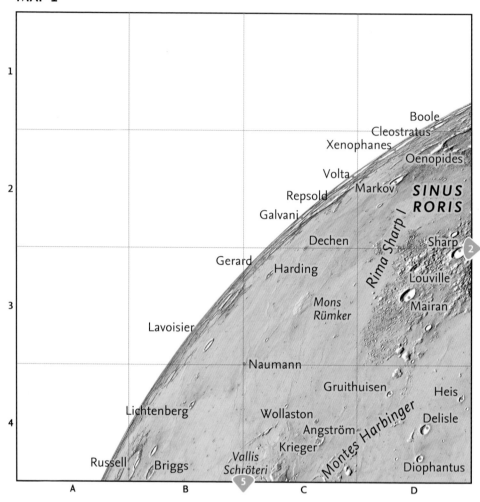

Sinus Roris (Bay of Dew), see D2, gives way to the northern edge of Oceanus Procellarum (Ocean of Storms) see page 44 B4. This is a very smooth region of the lunar surface, but not devoid of interesting features. Mons Rümker (named for the German astronomer Carl L. C. Rümker), see C3, is a prominent volcanic formation approximately 70 km wide, and over 1 km high at its peak. It's a dramatic sight during the waning days of the lunar cycle.

PLATE 1

This spread shows the area of the Moon covered by map 1 and image plate 1, as indicated by the green box in the locator map to the left. The map on page 36 also has green indicators that show the adjoining atlas page numbers to help you to navigate around the atlas. There are overlapping sections between all of the maps to assist with this. Named craters have a red locator dot while other features are identified by their name and type. Features can be quickly located on the maps using the Lunar Index (see page 94), which gives page references and the alphanumeric grid position.

MAP 2

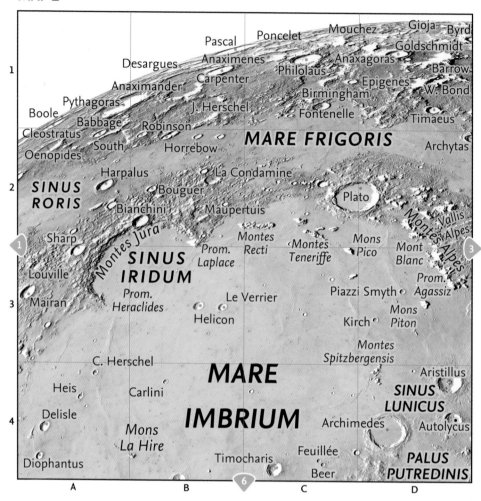

Sinus Iridum (Bay of Rainbows), see B3, and Plato crater, see C/D2, dominate the northern reaches of Mare Imbrium (Sea of Showers). They are respectively 250 km and 109 km across. Plato features an interesting rift in the western side of its rim. Many craters adorn the extreme northern latitudes, including Pythagoras with its twin 1.5-km-high peaks, see A1.

PLATE 2

This spread shows the area of the Moon covered by map 2 and image plate 2, as indicated by the green box in the locator map to the left. The map on page 38 also has green indicators that show the adjoining atlas page numbers to help you to navigate around the atlas. There are overlapping sections between all of the maps to assist with this. Named craters have a red locator dot while other features are identified by their name and type. Features can be quickly located on the maps using the Lunar Index (see page 94), which gives page references and the alphanumeric grid position.

MAP 3

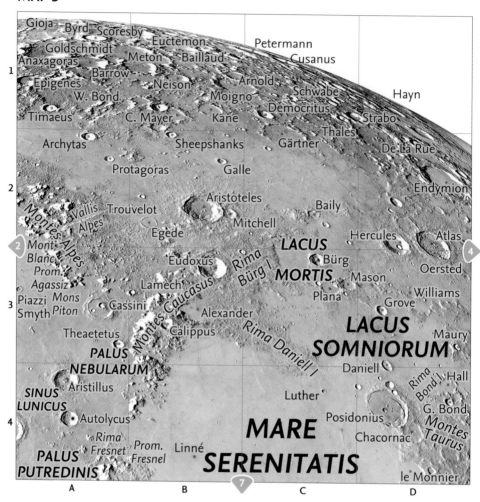

The striking Vallis Alpes (Alpine Valley), see A2, points us northeast toward a variety of small but rewarding craters in Mare Frigoris (Sea of Cold), see page 38 C2, including Galle (named for German astronomer Johann G. Galle, the first person to knowingly observe Neptune), see B2. Hercules and Atlas, see D2, are a wonderfully diverse pairing of craters to the east, and south of them, Posidonius , see D4, is full of interesting scars, craterlets and mountains.

PLATE 3

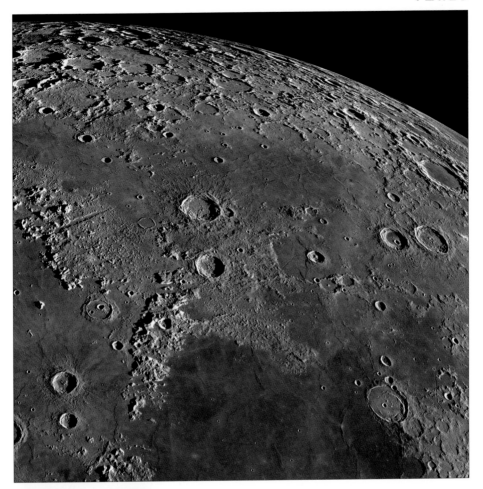

This spread shows the area of the Moon covered by map 3 and image plate 3, as indicated by the green box in the locator map to the left. The map on page 40 also has green indicators that show the adjoining atlas page numbers to help you to navigate around the atlas. There are overlapping sections between all of the maps to assist with this. Named craters have a red locator dot while other features are identified by their name and type. Features can be quickly located on the maps using the Lunar Index (see page 94), which gives page references and the alphanumeric grid position.

MAP 4

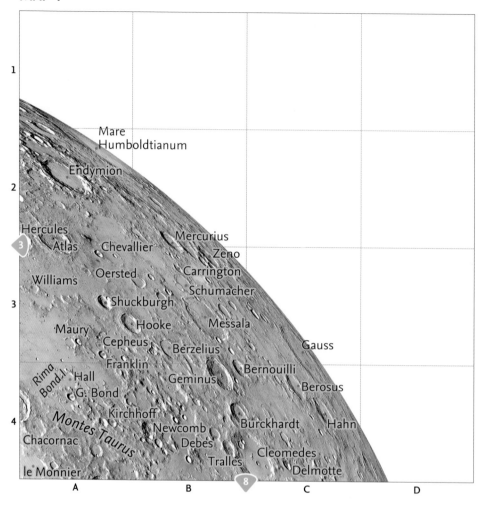

Endymion crater – about 125 km wide – helps us find Mare Humboldtianum (Sea of Alexander Von Humboldt, Prussian polymath), see A2, which is variously more or less favourable depending on libration.

Another extreme limb feature is Gauss crater (named for German scientist Carl F. Gauss), see C3. The floor of this crater is quite uneven, making it a great observing challenge at high magnification.

PLATE 4

1	2	3	4
5	6	7	8
9	10	11	12
13	14	15	16

This spread shows the area of the Moon covered by map 4 and image plate 4, as indicated by the green box in the locator map to the left. The map on page 42 also has green indicators that show the adjoining atlas page numbers to help you to navigate around the atlas. There are overlapping sections between all of the maps to assist with this. Named craters have a red locator dot while other features are identified by their name and type. Features can be quickly located on the maps using the Lunar Index (see page 94), which gives page references and the alphanumeric grid position.

MAP 5

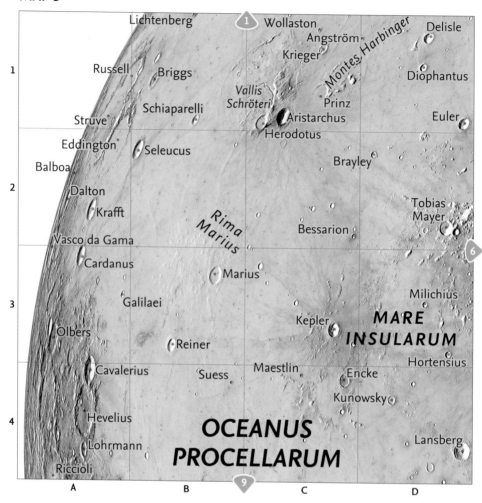

The enormous volcanic plain Oceanus Procellarum (Sea of Storms) is home to many famous craters. Aristarchus, see C1, the brightest crater on the Moon, lies just southeast of Vallis Schröteri (Schröter's Valley) – a snaking rille no more than 10 km wide. It is likely a collapsed lava tube.

Kepler crater (named for German scientist Johannes Kepler), see C3, has unmistakable rays stretching westward towards Galileai crater in A3 – a surprisingly modest tribute to Galileo for all his contributions to astronomy!

PLATE 5

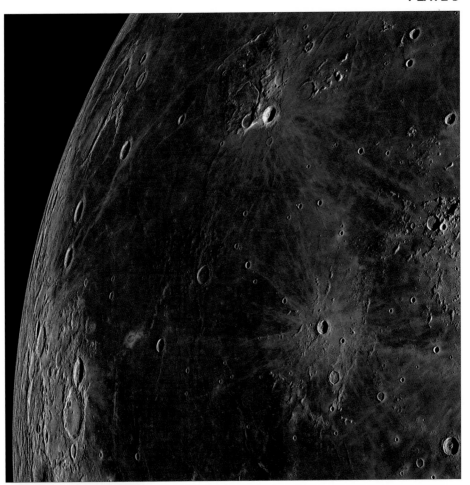

This spread shows the area of the Moon covered by map 5 and image plate 5, as indicated by the green box in the locator map to the left. The map on page 44 also has green indicators that show the adjoining atlas page numbers to help you to navigate around the atlas. There are overlapping sections between all of the maps to assist with this. Named craters have a red locator dot while other features are identified by their name and type. Features can be quickly located on the maps using the Lunar Index (see page 94), which gives page references and the alphanumeric grid position.

MAP 6

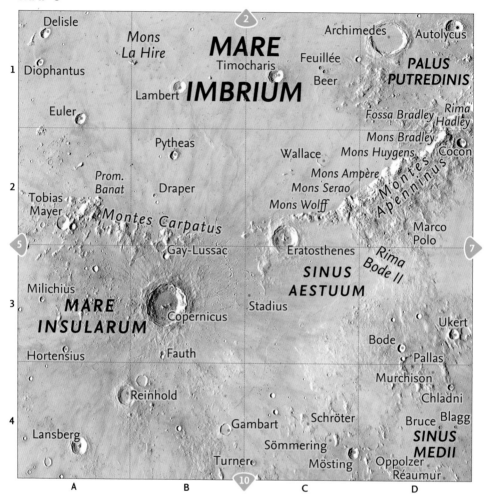

Copernicus crater (named for Polish astronomer Nicolaus Copernicus), see B3, is an unmissable highlight in Mare Insularum (Sea of Islands) see A3. Ninety-three km wide, and surrounded by a huge system of dramatic rays, this crater's terraced inner walls and complex system of peaks deliver remarkable views throughout the lunar month, as shadows creep across the terrain. To its north we find two mountain ranges – Carpatus (B2) and Appenius (D2) – which meet at Eratosthenes (a Greek mathematician who measured the size of the Earth in third century BCE). It's smaller than Copernicus at 59 km across, but no less beautiful to admire.

PLATE 6

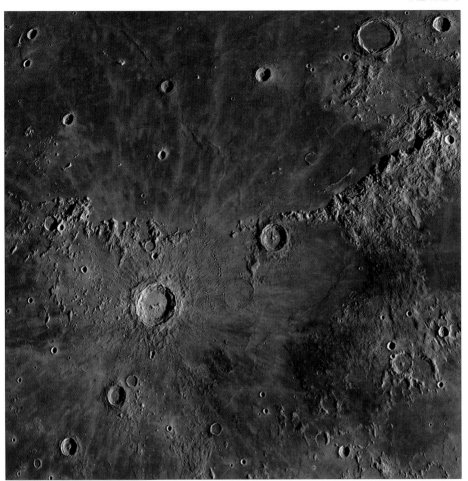

This spread shows the area of the Moon covered by map 6 and image plate 6, as indicated by the green box in the locator map to the left. The map on page 46 also has green indicators that show the adjoining atlas page numbers to help you to navigate around the atlas. There are overlapping sections between all of the maps to assist with this. Named craters have a red locator dot while other features are identified by their name and type. Features can be quickly located on the maps using the Lunar Index (see page 94), which gives page references and the alphanumeric grid position.

MAP 7

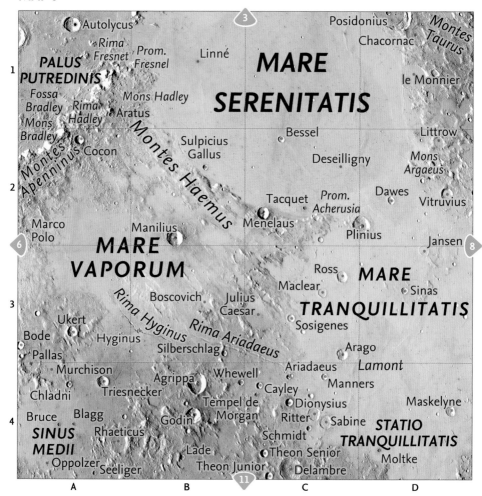

A diverse spread of rugged features occupies the intersection of three lunar seas: Mare Serenitatis (Sea of Serenity), Mare Tranquillitatis (Sea of Tranquility) and Mare Vaporum (Sea of Vapours). Among many small prominent craters are several subtle features, such as the shallow depression Julius Caesar, see C3, and Rimae Hyginus and Ariadaeus, see B3, (named for Gaius Julius Hyginus and Philip III of Macedon, respectively). Dawes crater (named after English astronomer William Rutter Dawes) is found where the rusty hued Mare Serenitatis meets the deep blue Mare Tranquillitatis, see D2.

PLATE 7

This spread shows the area of the Moon covered by map 7 and image plate 7, as indicated by the green box in the locator map to the left. The map on page 48 also has green indicators that show the adjoining atlas page numbers to help you to navigate around the atlas. There are overlapping sections between all of the maps to assist with this. Named craters have a red locator dot while other features are identified by their name and type. Features can be quickly located on the maps using the Lunar Index (see page 94), which gives page references and the alphanumeric grid position.

MAP 8

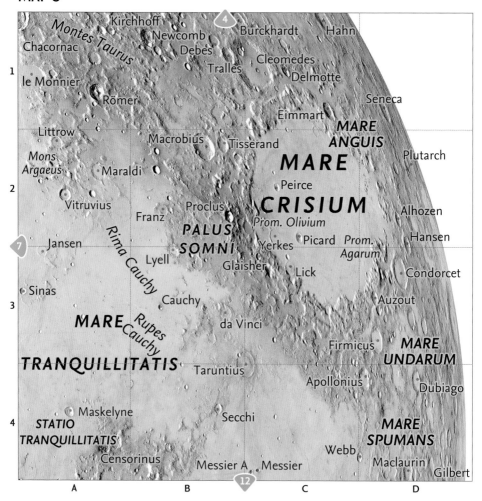

Mare Crisium (Sea of Crises) is a striking dark spot near the Moon's north-eastern limb. A relatively barren sea, it does still contain a few nice craters, including the ancient Picard, see C2. (Named for French astronomer Jean Picard – not a Starfleet Captain!) The brownish-grey Palus Somni (Marsh of Sleep),

see B2, is an interesting region adjoining the prominent crater Proclus (named for the Greek philosopher) whose rays set the marsh's eastern boundary. Proclus is 28 km in diameter and is the second brightest crater on the Moon.

PLATE 8

This spread shows the area of the Moon covered by map 8 and image plate 8, as indicated by the green box in the locator map to the left. The map on page 50 also has green indicators that show the adjoining atlas page numbers to help you to navigate around the atlas. There are overlapping sections between all of the maps to assist with this. Named craters have a red locator dot while other features are identified by their name and type. Features can be quickly located on the maps using the Lunar Index (see page 94), which gives page references and the alphanumeric grid position.

MAP 9

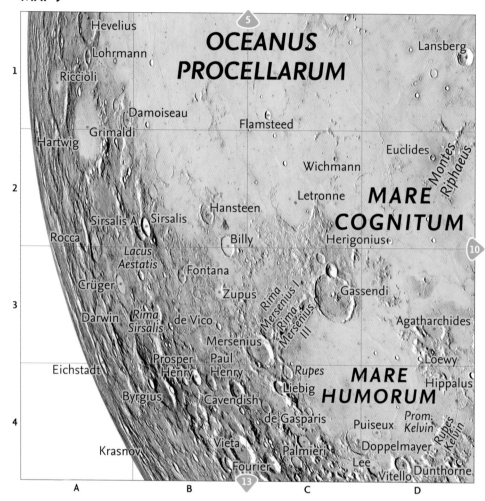

Crater Gassendi (named for French philosopher Pierre Gassendi), see C3, is resplendent with floor features, including a complex system of rilles collectively known as Rimae Gassendi. The 100-km-wide crater straddles the northern edge of Mare Humorum (Sea of Moisture) and was once considered a landing site for Apollo 17. Grimaldi crater (named for Italian mathematician Francesco M. Grimaldi), see A1/2, near the western limb has the appearance of a luanr sea, but is in fact a depression formed by an ancient impact.

PLATE 9

This spread shows the area of the Moon covered by map 9 and image plate 9, as indicated by the green box in the locator map to the left. The map on page 52 also has green indicators that show the adjoining atlas page numbers to help you to navigate around the atlas. There are overlapping sections between all of the maps to assist with this. Named craters have a red locator dot while other features are identified by their name and type. Features can be quickly located on the maps using the Lunar Index (see page 94), which gives page references and the alphanumeric grid position.

MAP 10

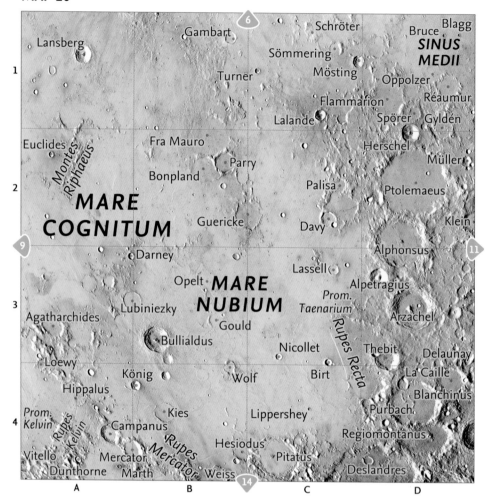

There are no continuous features separating Mare Cognitum (The Known Sea) and Mare Nubium (Sea of Clouds) but rather a smattering of sunken craters. Bullialdus (named for French astronomer Ismaël Bullialdus), see B3, stands out prominently, with a considerable depth of 3.5 km. Another popular favourite is Arzachel (named for Spanish-Arabic astrologer Abū Ishāq Ibrāhīm al-Zarqālī), see D3, which boasts an even greater depth of 3.6 km, a large central peak and an accompanying craterlet. Rupes Recta, a linear fault, see C3/4, is a very unique feature, just a few hundred metres tall. It is sometimes mistaken for an eyelash on the observer's eyepiece!

PLATE 10

This spread shows the area of the Moon covered by map 10 and image plate 10, as indicated by the green box in the locator map to the left. The map on page 54 also has green indicators that show the adjoining atlas page numbers to help you to navigate around the atlas. There are overlapping sections between all of the maps to assist with this. Named craters have a red locator dot while other features are identified by their name and type. Features can be quickly located on the maps using the Lunar Index (see page 94), which gives page references and the alphanumeric grid position.

MAP 11

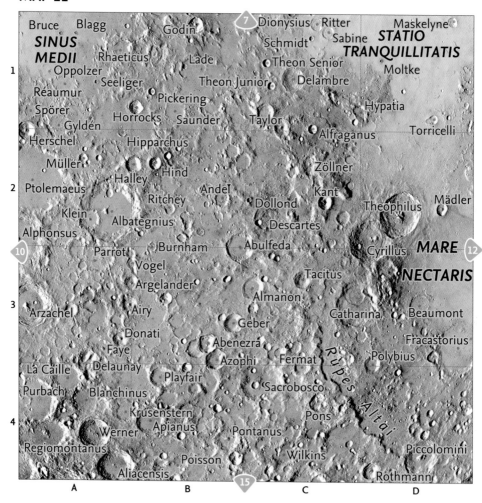

Many beautiful craters fill this busy region, offering a lifetime of viewing for any moongazer. Don't miss the 427-km-long enscarpment Rupes Altai, see C/D4 and to its north a famous trio – Theophilus, Cyrillus and Catharina (named for religious figures), see D2 and C3. From north to south, they become less defined, illustrating their relative ages. Catharina, the oldest of the three, is has been most eroded by material from other impacts.

PLATE 11

This spread shows the area of the Moon covered by map 11 and image plate 11, as indicated by the green box in the locator map to the left. The map on page 56 also has green indicators that show the adjoining atlas page numbers to help you to navigate around the atlas. There are overlapping sections between all of the maps to assist with this. Named craters have a red locator dot while other features are identified by their name and type. Features can be quickly located on the maps using the Lunar Index (see page 94), which gives page references and the alphanumeric grid position.

MAP 12

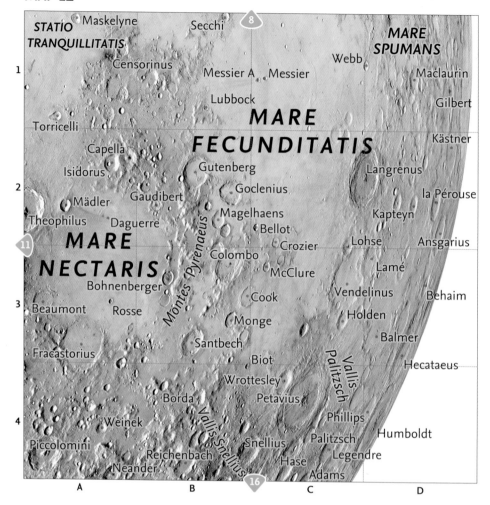

MARE
SPUMANS

STATIO
TRANQUILLITATIS

Maskelyne

Secchi

8

Censorinus

Webb

1

Messier A · Messier

Maclaurin

Lubbock

Gilbert

Torricelli

MARE

Capella

FECUNDITATIS

Kästner

Isidorus

Gutenberg

Langrenus

2

Goclenius

la Pérouse

Mädler

Gaudibert

Theophilus

Daguerre

Magelhaens

Kapteyn

Bellot

11

MARE

Colombo

Crozier

Lohse

Ansgarius

NECTARIS

McClure

Lamé

Bohnenberger

Cook

Vendelinus

Behaim

3

Beaumont

Rosse

Monge

Holden

Fracastorius

Santbech

Balmer

Biot

Hecataeus

Wrottesley

Borda

Petavius

4

Weinek

Phillips

Piccolomini

Snellius

Palitzsch

Humboldt

Reichenbach

Hase

Legendre

Neander

Adams

16

Montes Pyrenaeus

Vallis Palitzsch

Vallis Snellius

A · B · C · D

Mare Nectaris (Sea of Nectar) and Mare Fecunditatis (Sea of Fertility) are separated by Montes Pyranaeus, see B2/3, which lead us north to the 74-km-wide Gutenberg crater (named for German inventor Johannes Gutenberg), see B2. Two larger craters, Langrenus (after the Dutch astronomer), see C/D2 and Petavius (after the French theologian Denis Pétau), see C4, with their textured rims offer fine views in the morning light during the early days of the lunar month.

PLATE 12

1	2	3	4
5	6	7	8
9	10	11	12
13	14	15	16

This spread shows the area of the Moon covered by map 12 and image plate 12, as indicated by the green box in the locator map to the left. The map on page 58 also has green indicators that show the adjoining atlas page numbers to help you to navigate around the atlas. There are overlapping sections between all of the maps to assist with this. Named craters have a red locator dot while other features are identified by their name and type. Features can be quickly located on the maps using the Lunar Index (see page 94), which gives page references and the alphanumeric grid position.

MAP 13

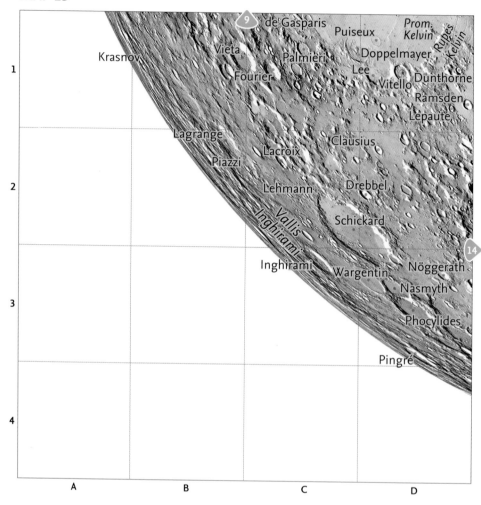

The large crater Schickard (named after the German astronomer Wilhelm Schickard), see C2, is one of the most dramatic features on the Waning Crescent Moon during the final days of the lunar month. Looking west from its 227-km-wide basin to the lunar limb, we find Inghirami crater, see C3, and its accompanying valley (named for Italian astronomer Giovanni Inghirami), see C2. Both are very sensitive to libration and make fine challenges for the experienced moongazer.

PLATE 13

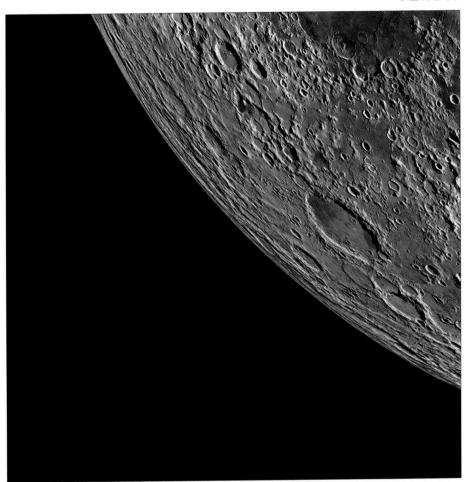

This spread shows the area of the Moon covered by map 13 and image plate 13, as indicated by the green box in the locator map to the left. The map on page 60 also has green indicators that show the adjoining atlas page numbers to help you to navigate around the atlas. There are overlapping sections between all of the maps to assist with this. Named craters have a red locator dot while other features are identified by their name and type. Features can be quickly located on the maps using the Lunar Index (see page 94), which gives page references and the alphanumeric grid position.

MAP 14

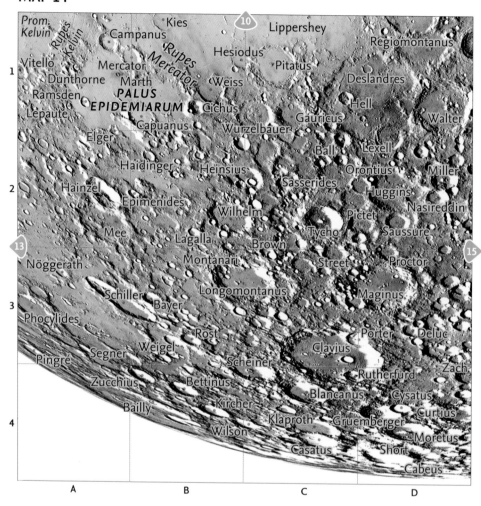

The craters Clavius (named after German mathematician Christopher Clavius), see C3, and Tycho (after Danish astronomer Tycho Brahe), see C2, dominate the western side of the lunar southern highlands, where countless craters fight for attention. The former contains many sizable craterlets in its 3.5-km-deep basin, all of which appear elongated at the angle we see them. The latter is one of the deepest craters on the Moon at 4.8 km and about 108 million years old. Its striking central peak has been well studied from Earth and lunar orbit. Both are generous targets for observers and astrophotographers alike.

PLATE 14

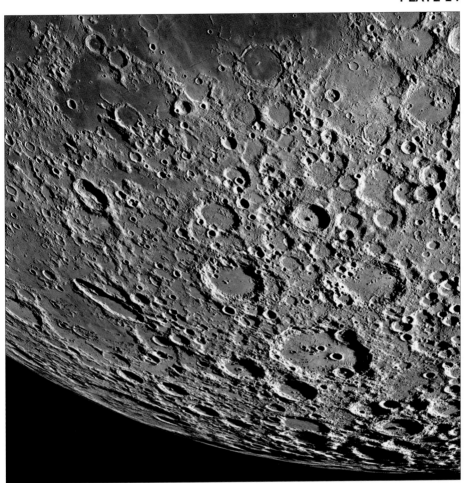

This spread shows the area of the Moon covered by map 14 and image plate 14, as indicated by the green box in the locator map to the left. The map on page 62 also has green indicators that show the adjoining atlas page numbers to help you to navigate around the atlas. There are overlapping sections between all of the maps to assist with this. Named craters have a red locator dot while other features are identified by their name and type. Features can be quickly located on the maps using the Lunar Index (see page 94), which gives page references and the alphanumeric grid position.

1	2	3	4
5	6	7	8
9	10	11	12
13	14	15	16

MAP 15

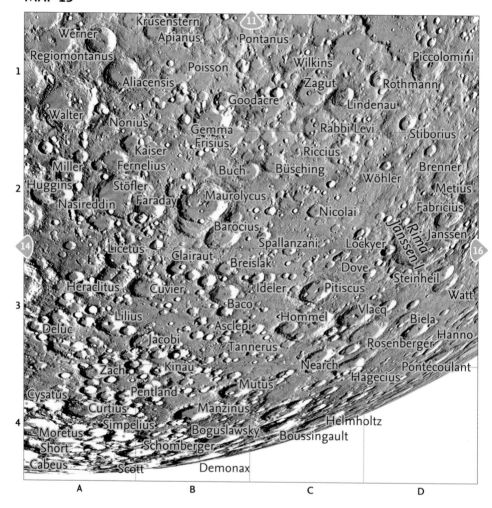

Among dozens of prominent craters, Maurolycus (named after the Sicilian mathematician Francesco Maurolico), see B2, boasts the most obvious mountainous peak. Its eastern wall is nicely terraced, whereas the northwest of its rim has been eroded by subsequent impacts. To the east we find the relatively shallow but ancient Janssen crater (after French astronomer Pierre J. C. Janssen), see D2. Its structure has been largely destroyed and worn down by impacts, erosion and fractures, rendering a very interesting and rugged floor to explore.

PLATE 15

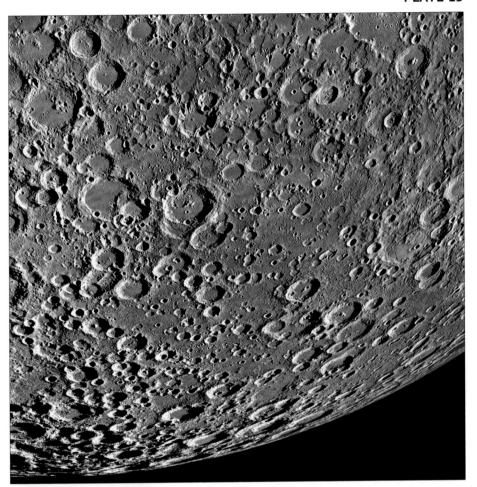

This spread shows the area of the Moon covered by map 15 and image plate 15, as indicated by the green box in the locator map to the left. The map on page 64 also has green indicators that show the adjoining atlas page numbers to help you to navigate around the atlas. There are overlapping sections between all of the maps to assist with this. Named craters have a red locator dot while other features are identified by their name and type. Features can be quickly located on the maps using the Lunar Index (see page 94), which gives page references and the alphanumeric grid position.

1	2	3	4
5	6	7	8
9	10	11	12
13	14	15	16

MAP 16

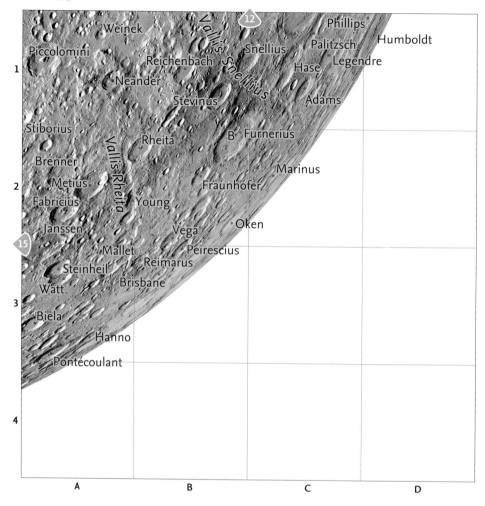

The valleys Rheita (named after Czech instrument maker Anton M. Schyrleus of Rheita), see A2, and Snellius (after Dutch astronomer Willebrord Snellius), see B1, take their names from their accompanying craters. Both are broad linear valleys, some tens of kilometres wide, and are eroded by recent impacts. Being rather unobvious, they are rewarding challenges to find. Furnerius crater (after French geographer Georges Fournier) is a large, deep basin with a prominent inner crater (B) on its interior floor, see B2.

PLATE 16

This spread shows the area of the Moon covered by map 16 and image plate 16, as indicated by the green box in the locator map to the left. The map on page 66 also has green indicators that show the adjoining atlas page numbers to help you to navigate around the atlas. There are overlapping sections between all of the maps to assist with this. Named craters have a red locator dot while other features are identified by their name and type. Features can be quickly located on the maps using the Lunar Index (see page 94), which gives page references and the alphanumeric grid position.

Lunar Astrophotography

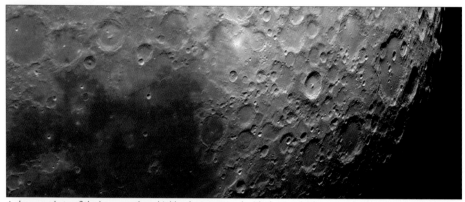

A close-up photo of the lunar southern highlands, as captured with the Royal Observatory's Great Equatorial Telescope.

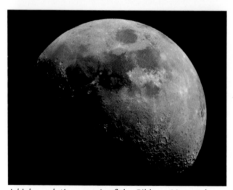

A high resolution mosaic of the Gibbous Moon taken using the Annie Maunder Astrographic Telescope in Greenwich.

Whether you are a novice or a seasoned astrophotographer, the Moon is an excellent photographic subject, offering both challenge and reward in equal measure. As we have seen, its visage is endlessly changing, offering unique views as the lunar month passes. In this chapter, we'll explore various methods for capturing images of the Moon, and processing them to reveal its features and other properties.

As we have seen, the Moon's angular size is smaller than it appears, subtending at most a little more than half a degree in apparent diameter. Consider your own field of vision. Many point-and-shoot cameras are designed to replicate what we see, and as such reproduce the Moon as a very small object in the final picture. Even sophisticated smartphone cameras can at best resolve only very large features on the surface of the Moon.

In order to capture the full range of surface features in detail, we need the magnification afforded by a telescope to resolve them. Of course, some large camera lenses are essentially small telescopes, and therefore without buying any dedicated astronomy equipment, you may already have what you need to photograph the Moon. If you do own a telescope, the camera on your smartphone is a good place to start.

The nearly Full Moon, captured using a smartphone camera with no additional optics.

Afocal Smartphone Photography

Because many of us carry high resolution cameras with us at all times, it's possible to get started with photographing the surface of the Moon through the eyepiece of a telescope with just a smartphone. Using a camera with its own lens to photograph objects through an eyepiece is known as afocal photography (not to be confused with eyepiece projection, which involves projecting the eyepiece image directly to an exposed sensor). This is an inviting way to practise astrophotography, with the Moon serving as a generous target for small cameras, but there are some frustrating pitfalls to avoid.

Initially, as with most aspects of astronomy, it's better to start at a lower magnification. If your telescope is not capable of tracking the Moon, consider using the lowest possible magnification to begin with. In this way,

the Moon will remain in the field of view for longer, giving you extra time to steady your shot and correct its exposure. Because the Moon subtends slightly more than half a degree on the sky, a true field of view of between one and two degrees is ideal. Most basic eyepieces, such as Plössls, have an apparent field of view of about 50 degrees. Targeting a true field of between one and two degrees, you should aim for a magnification of between 25–50 times. For more on choosing and using eyepieces, see page 29.

Your low power view will present the entire lunar disk in good detail, but also allow generous time for it to cross the field of the eyepiece. If your telescope is tracking, ensure the Moon is centred in the field, as the image is relatively free of optical aberrations here. Otherwise, anticipate the drift of the Moon through the field and place the centre of your field of view ahead of its

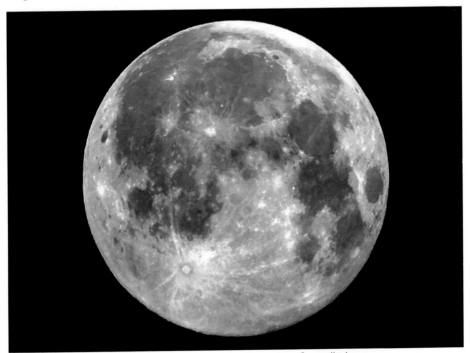

The Full Moon, captured using a smartphone connected to the eyepiece of a small telescope.

path. With care, you can still achieve very nice results using a non-tracking telescope as the Moon drifts through the field.

In practise you will find that holding your phone steady at the eyepiece of a telescope is quite difficult. When we look with our eyes, our vision is steadied effortlessly as our brains compensate for the movements of our heads. Human vision is perfectly stabilised, but our hands are far less steady. The problem is exacerbated by the need to touch the device to capture a photo. You will often find yourself perfectly lined up for a shot, only to spoil it when pressing gently on the screen of your phone. There are however some ways to overcome this problem, utilising extra equipment that has entered the market in response to the rise in popularity of smartphone photography.

A digiscoping adapter is an excellent tool for afocal photography. It allows you to pair your phone to an eyepiece for hands-free shooting, and line up the phone camera's lens to the optical axis of the telescope for best results. Digiscoping adapters are available from a variety of manufacturers, but when purchasing one, you should consider the eyepieces in your collection. Not all eyepieces are useful for digiscoping. So-called 'volcano top' eyepieces – those

with smooth sloping sides around the eye lens – are particularly unsuitable because digiscoping adapters cannot be secured to them.

Most modern smartphones are large and quite heavy, and a secure pairing is essential to avoid dropping your expensive device several feet! Check the specification of the adapter to ensure it is suitable for the size and design of your eyepieces, or contact a dealer for further advice. The US-based company Tele Vue manufactures an adapter specially designed for many of their own eyepieces, proving the most secure solution.

Due to the high dynamic range and contrast of the Moon against the sky, it is generally difficult for smartphone cameras to automatically determine the optimal settings. A common frustration in practising afocal photography, even with a digiscoping adapter, is the inability of many smartphone cameras to correctly focus and expose the lunar disk. 'Tap-to-focus' can also prove less than useful, particularly when the Moon is thinly illuminated during the crescent phases. Fortunately there are ways to control the exposure and focus settings more precisely, though not all smartphones allow such adjustment by default. If your device has a pro or manual mode in its

Left: A 'volcano top' eyepiece, with a sloping top. Right: a straight-sided eyepiece.

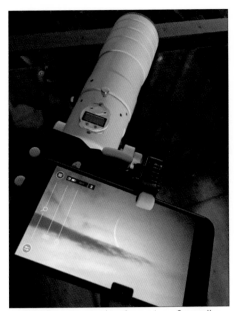

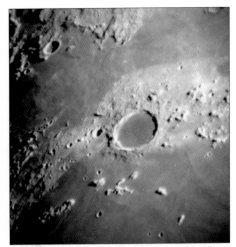

Plato Crater and the surrounding terrain, captured using a smartphone camera at the eyepiece of the Great Equatorial Telescope, viewing at high power.

A smartphone connected to the eyepiece of a small telescope using a digiscoping adapter, pointed at the Crescent Moon.

camera app, you should enable this. If not, consider one of the many capable apps available that unlock additional camera features. Examples include ProCamera and NightCap Camera, both of which enable precision manual adjustment. Such apps also allow you to capture raw image data – preserving detail in the form of colour depth – in an uncompressed format. This enables greater range for post-processing the shot, and as we will see later in this chapter, uncompressed image data is the key to advanced lunar photography.

One final hurdle is vibration caused by touching the device. A simple way to overcome this is to enable a timer of about three seconds, such that any vibrations imparted when the timer begins will cease before the shot is taken. Alternatively, there are many inexpensive remote shutters – most operated by Bluetooth – which are compatible with virtually all modern smartphones. A secure digiscoping adapter,

combined with a remote shutter and manual exposure control app, will result in a very simple and gratifying start to telescopic astrophotography. When you're confident with your own method, you can progress to high magnifications, ultimately capturing detailed images of small lunar features using a device that fits in your pocket – a feat that would astonish any lunar observer just a generation ago!

Wide-Angle and Telephoto Lunar Photography

As we've seen, the Moon's angular size is very

Wide-angle view of the Moon with a DSLR.

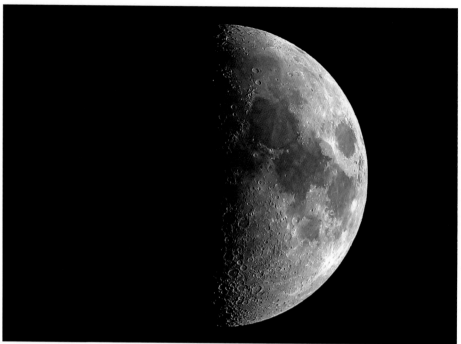

Telephoto lenses can show significantly more detail.

similar to that of the Sun, and it is therefore rather small when photographed with a wide-angle lens. Telephoto lenses of between 200–500 mm focal length can readily resolve its large, prominent features. Of course, like the Sun, the Moon is a natural source of light – specifically sunlight, albeit dialled back in brightness approximately 400,000 times! Nevertheless, with careful attention to the rules of low-light photography, the Moon's light can be used to illuminate a landscape in a wide-angle shot. Alternatively, with a

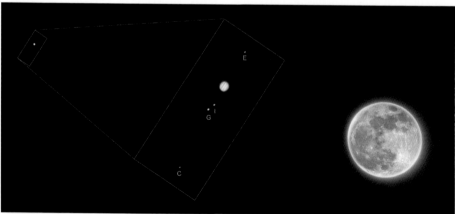

A conjunction of the Moon and Jupiter, with the planet's Galilean satellites also visible. Io (I), Europa (E), Ganymede (G) and Callisto (C).

A total lunar eclipse seen from Greenwich, London in 2015. The Full Moon is entirely within the darkest region of the Earth's shadow – the umbra.

longer lens, the Moon becomes a dramatic backdrop to features on the horizon when it is rising or setting.

Standard camera lenses also offer a good compromise between simplicity and quality when capturing special events, such as conjunctions with planets and eclipses. Atmospheric phenomena such as moonbows can also be captured.

One popular technique for recreating the unique quality of looking at the Moon visually is to utilise High Dynamic Range (HDR) capture and processing. HDR photos are made from a combination of at least two different exposures, taken in quick succession, allowing both shadow and highlight detail to be recovered across the scene. A Full Moon is easy to overexpose when attempting to capture other parts of a landscape scene, but an HDR composite will preserve its distinctive face. Many modern cameras support automatic HDR bracketing, and software such as Photomatix

can automatically work with sets of photos to greatly improve dynamic range.

When the Moon is thinly illuminated, long exposures can capture earthshine. As we

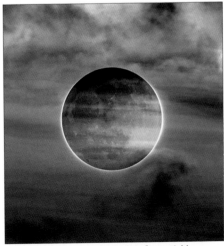

A high dynamic range composite of a partial lunar eclipse behind dramatic clouds. Details are visible in the Earth's shadow, but highlights are not overexposed.

have already seen, this phenomenon occurs because sunlight is reflected from the Earth to the Moon and back again. Earthshine is a nice reminder that the phases of the Moon occur due to illumination, not because it is changing shape or passing into the Earth's shadow.

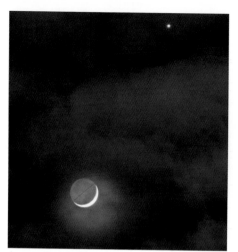

A young Crescent Moon in conjunction with Venus. The Moon's nightside is seen with earthshine in this deliberately overexposed shot.

Lunar Photography with a Telescope

The Moon is by far the simplest astronomical target to attempt when beginning astrophotography with a telescope. Its brightness is sufficient to allow for short exposures, but it does not require special filters to safely observe. We'll consider using both DSLR cameras and specialist astronomy cameras.

It's important to understand the capabilities of your telescope. The apparent size of the Moon as presented to the camera (known as the sample resolution) will depend on the focal length, whereas the ability to resolve fine detail is related to the aperture (with the atmospheric conditions imposing a limit). Focal length and aperture together determine photographic speed, which is worth our consideration if we are attempting to take very short exposures.

If your telescope is not tracking, it is essential to keep your exposures short. The Moon drifts at a unique rate across the sky, largely with the stars, but partially against them as it gradually crawls around its orbit. Most tracking telescopes with GoTo functionality (the ability to find objects in the sky) are capable of moving at the lunar rate for precise tracking. Such telescopes offer the greatest advantage for taking very detailed images. When purchasing a telescope, you should express your wish to do photography to your dealer, as they will have up-to-date knowledge about which current models will suit your needs.

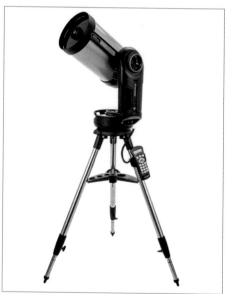

A GoTo telescope with a computerised mount, capable of finding and tracking objects in the sky.

In essence, every telescope, regardless of its design, can be considered to be a finely made prime focus lens. Using it with your DSLR camera is a matter of adapting it to the camera's mount. Telescope focusers come in two common diameters – 31.7 mm

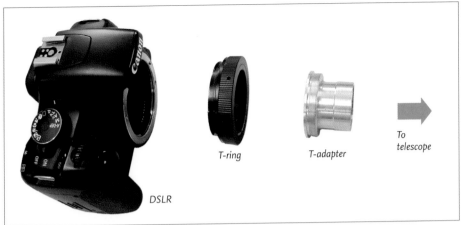

Connecting a DSLR to a telescope using a T-adapter and T-ring.

(1.25 in.) and 50.8 mm (2 in.) – and so called T-Adapters are widely available to fit both. These adapters have an industry standard 42-mm male thread, known as a T-Thread. The final component necessary to attach your DSLR is a brand-specific T-Ring, which has a corresponding female T-thread and lens mount rings designed to fit a particular standard. For Canon cameras this is known as an EF-mount; Sony utilises Minolta's A-mount; Nikon the F-mount.

Not all telescopes can come to focus with a DSLR and T-adapter. This is due to the fact that DSLR sensors are set back inside the camera quite far behind the mirror. You may find that you can't focus inward enough to produce a sharp image on your camera's screen. If this is the case, you can use a Barlow lens to add infocus to the optical system. Note that a Barlow lens will amplify the telescope's power, usually by a factor of two, resulting in double the magnification and one quarter the image brightness.

With your telescope and camera ready, it's time to take images! In astrophotography it is essential to take images in the highest quality your equipment will allow. DSLR cameras allow for shooting raw files (CR2, NEF, DNG, etc.), which are essentially digital negatives. That is, they preserve all the data gathered by the sensor, allowing for much greater latitude in processing images. Compressed files, such as JPEGs, sacrifice many shades of colour and brightness, as well as fine resolution, to reduce the file size. Even an excellent JPEG is significantly inferior to a raw file, due to its low bit-depth. JPEGs record colour information in 8-bit, resulting in a total 16.8 million possible colours to be represented. This seems like a lot, but raw files preserve about 281 trillion (!) different colours – far more than you can see on a digital screen, but plenty to work with at the processing stage. The table on the following page illustrates the practical results of compromising data at the capture stage. With memory cards and storage becoming so inexpensive, it's well worth shooting and keeping all your astronomical images as raw files.

As we'll see later in this chapter, colour information can be very interesting when photographing the Moon, and your DSLR should always be set to shoot in colour. If you want to preview the shots accurately, set your white-balance to daylight (moonlight is sunlight) and note that when shooting raw images, the colour balance can be adjusted at a later stage without compromising quality.

RAW (CR2, NEF, DNG)
Colour depth

Number of shades per colour - 65,535 16-bit (smooth gradients)
Number of colour combinations - 281 trillion

JPEG
Colour depth

Number of shades per colour - 256 8-bit (colour banding)
Number of colour combinations - 16.7 million

RAW files vs JPEG files. Due to the limitations of the printing process this is for illustrative puropses only.

For the sharpest images, short exposure times are necessary. Even if your telescope is tracking, astronomical seeing will negatively affect the focus and geometry of the resultant images, increasing their apparent blurriness. The impact depends entirely on how long the shutter is open. On the other hand, keeping the ISO setting as low as possible is better, to minimise digital noise. In practise, this will require trial and error to get right. In the next chapter we'll explore ways to combat noise in lunar images. To begin with, particularly when the Moon is generously illuminated, you can typically take photographs with shutter speeds faster than 1/250th of a second at ISO 400 or 800 using a variety of telescopes. The Moon's brightness is very forgiving, so don't fret too much about photographic speed. Just get out there and see what your camera can do!

The highest quality photos of the lunar surface, presenting its features in extraordinary detail, are almost always taken using specialist astronomy cameras. In the vast majority of cases, these cameras are intended for planetary, lunar and solar imaging, and are compact in size. For this reason, they typically have a 31.7-mm barrel, just like a standard eyepiece. They are designed to be placed straight into the telescope focuser and, due to their design, come to focus with almost all telescopes. Notable manufacturers of such cameras are ZWOptical and The Imaging Source. Within the market of planetary cameras, there are many differences in design and price, and it's always best to consult a dealer to see what's available for your budget before buying.

A ZWOptical camera.

An Imaging Source camera.

These cameras are not standalone devices, but require a computer to run through a USB. When evaluating a laptop for astrophotography, ensure that its USB provides plenty of power, as some cameras require this to maintain a live connection. On the computer end, software is used to record a video file directly to the computer's hard drive – yes, a video rather than an image! Typical file formats are AVI or SER. As we will see, accurate lunar imaging requires gathering multiple exposures of the same field. In fact, it is advisable to capture no less than 500 frames of video for a single image!

The free software FireCapture works with a wide range of planetary cameras, and offers lossless recording with many useful features. From its interface you can adjust the exposure time, gain and select a region of interest within the frame. Selecting a smaller area will improve the frame rate of the recording, allowing faster data capture, if your camera has a very high resolution sensor. USB 3.0 cameras can record well over 100 frames per second at some resolutions.

Planetary cameras are usually available in monochrome or colour variants. If your intention is to take the highest resolution images of the Moon your equipment will allow, you should consider a monochrome camera. It will only generate black and white images, but as a trade-off, its effective resolution will be better. Additionally, black and white images can be improved with the use of filters.

Due to the composition of the Earth's atmosphere, blue light is very perturbed relative to red light. It is scattered preferentially, resulting in a blue sky, whereas red light passes through the atmosphere relatively unaffected. For observers on the ground, this has a curious consequence. Red images are more stable than blue ones. Filtering for just red light actually mitigates the effect of the atmospheric seeing. In fact, red light images of the Moon can be significantly better than images taken across the visual spectrum. Earlier in this book we saw that viewing the Moon through an orange (no. 21) filter can improve the view with a medium size or large telescope. For a camera with adjustable sensitivity, a light red (no. 23A) or red (no. 25) filter will improve the clarity of the image at the capture stage. Indeed, some monochrome cameras are sensitive to the infrared, which is even cleaner than the visual red light passing through our atmosphere, and infrared filters are available. However, red filters suffice quite well and are also useful for visual observing. Furthermore, in smaller telescopes, infrared filters will significantly darken the image as seen by the camera's sensor.

A no. 23A light red filter.

A no. 25 medium red filter.

An infrared pass filter, only allowing wavelengths longer than 742 nm to be transmitted.

Whether using a DSLR or dedicated astronomy camera, there is an important piece of theory to consider in astrophotography, which will take our lunar images to the next level.

Understanding Signal-to-Noise Ratio (SNR)

As astrophotographers, we are attempting to capture light from the Universe, but digital cameras are subject to digital noise being generated by the electronics of the sensor. For every 100 packets of light (photons) that arrive from space and land on our camera's

sensor, there is a chance that the camera will record more than 100. These extra counts are digital noise, sometimes called dark current. Suppose we record 110 counts for every 100 real photos in an image. We would describe the image as having a signal-to-noise ratio (SNR) of 100:10 or, to reduce it to the smallest denominator, 10:1. For every 10 real bits of signal, we end up with one bit of noise. This noise is evident in digital photos, and particularly so when light levels are low. In very fast exposures with high ISO (or gain) settings, noise will be even more prevalent. The degree of noise is also dependent on the temperature of the sensor, which changes while it is in use.

The presence of noise is a problem in astrophotography. If we intend to brighten our image, as in the case of a galaxy or nebula, we will also brighten the noise. If we want to sharpen our image, which is crucial to revealing lunar details, we will greatly exacerbate noise. Later in the chapter we'll see that our method of sharpening, known as iterative deconvolution, requires very low noise, so what can we do to help ourselves?

The key is to improve the SNR – to achieve an image that is signal dominated, pushing the noise level as low as possible. Every exposure we take has inherent noise, as does every frame of video from a dedicated planetary camera, but it is stochastic in nature. Every image has a similar noise profile, but the location of the noise changes. Meanwhile, the signal is more consistent, because it represents real light from a real feature of the lunar surface. By combining multiple exposures using a signal processing algorithm, we can produce an image with a higher SNR than any individual exposure. In astrophotography nomenclature, the individual images are often called subframes, and the process of combining them to improve SNR is known as stacking. Stacked exposures appear much cleaner, if a little blurrier, as shown here.

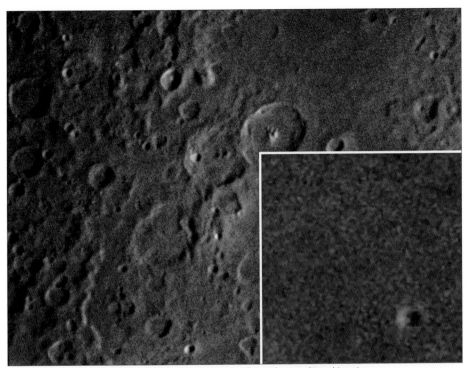

Digital noise in a single subframe. Sharpening the image will greatly exacerbate this noise.

Left: a single subframe. Right: a stacked image composed from multiple subframes.

This process provides an additional benefit for lunar imaging. Due to the rapidly moving air in the atmosphere, the geometry of any given feature is constantly changing. From one moment to the next a crater, for example, will appear to change shape, but there is a true shape, and we would like to accurately represent it in our final image. We assume that the atmospheric seeing, given enough time, creates an even amount of distortion across the image. We can imagine this distortion as a kind of natural blur filter. By taking many exposures over a long period of time, our high SNR image is normalised to represent the average geometry of each feature, which will closely match the true geometry.

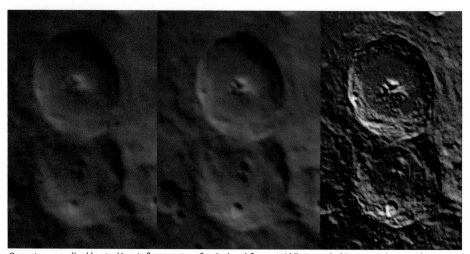

Geometry normalised by stacking. Left: geometry of a single subframe. Middle: a stacked image. Right: Actual geometry.

Processing Videos and Images

To follow this guide, you will need to first acquire a number of images of the Moon from either a DSLR or high frame rate imaging camera. Your images should be raw stills or video sequence files respectively. The pictures (screenshots) in this chapter are based upon a close-up view of the lunar surface captured as video frames. For DSLR images, see later in the chapter on page 85 for a pre-processing guide.

1. The first stage of your processing workflow is to convert your collection of images into a single, high-SNR master image. This involves several steps, but they can all be performed sequentially by the free software AutoStakkert! It is a very capable image calibration suite, performing analysis, alignment and stacking. Begin by opening your video file, or simply dragging it onto the AutoStakkert! window. Using the analysis tool, we ask the software to evaluate the subframes and score them by quality. For very large numbers of frames, such as hundreds or thousands, only a certain number or percentage (those deemed to be sharpest and clearest) need to be stacked for the final image. Ensure that AutoStakkert! is correctly set to planet mode (for the full lunar disk) or surface mode (for a region of the lunar surface) before analysis. If you are in surface mode, you will need to hold control (CTRL) and left click on a feature to use as an anchor. If the tracking of the telescope during capture was not precise, you can tell AutoStakkert! to crop the resultant image, such that only parts of the surface visible in every image appear in the

The main AutoStakkert! window with an AVI file imported.

A quality graph after analysis of all frames.

Alignment points added to the reference frame for stacking.

final result. This will reduce the resolution of the final image, but will also prevent artefacts from occurring at the next stage. Once analysis is complete, the software will allow you to add alignment points in the image window. You can automatically add points, but you may wish to adjust the **Min Bright** setting if features are too dark to be detected. In the top right of the information window is a box in which you can enter the number or percentage of frames you would like to stack. There are no set rules here. My advice is to produce an image with between 70 to 300 frames, depending on the overall quality of the atmospheric seeing. For example, if it was a steady night and you captured 3,000 frames, stack the best 10 per cent. If you captured 500 frames, 10 per cent will be too few for a clean enough result, so manually choose 70 or 100. If you combined fewer than 100 DSLR images into a video, stack 100 per cent of frames. Leave the output file type as TIF and press Stack. AutoStakkert! will produce a master image in a new folder alongside your source video. This high-SNR image will be our basis for the next stage.

2. After stacking subframes, we're ready to deconvulve (sharpen) the master image and see how much detail we've captured. We'll use another free program, RegiStax, to perform this step. RegiStax is also capable of stacking images, but AutoStakkert! produces better results, particularly on regions of the lunar surface. Drag your image into the RegiStax window. It may offer to stretch intensity levels if it detects that the image is overly bright or dark. You can select Yes and you'll be presented with the Wavelet tab. Wavelets are levels of contrast adjustment that RegiStax uses to perform iterative deconvolution. Each wavelet layer slider on the left-hand side of the window represents a scale in the image, with layer 1 being the largest. By adjusting these sliders, you'll see that a portion of your image changes appearance. You can click anywhere on your image to set the processing area, and see your changes applied. You can also click Do All to apply changes to the whole image. Note that these changes are not permanent, and you can undo them. This stage can be quite magical. Your clean but blurry image will come to life as the deconvolution algorithm, treating the atmosphere as a blur filter, runs the corresponding 'deblur' filter! Each wavelet layer can be individually tuned in both strength of deconvolution and noise reduction. You will need to play with these sliders and boxes extensively to produce a result you are happy with. Ultimately this is very subjective, and each astrophotographer has a personal limit at which point they regard images as having an 'overprocessed' appearance. When you are happy with your deconvolved image, click Do All and then Save Image. RegiStax will produce a sharpened TIFF file, which is ready for final adjustment.

3. There are many image manipulation programs that can be used to tweak your final image. Adobe Photoshop is a highly capable image package, and I have included screenshots of the software here. However a free alternative – GIMP – has almost all the same features. Regardless of what you use, ensure you are always working with 16-bit data until you finally export your JPEG image. In your image processor, you can enhance the contrast of your image to improve the perceived dynamic range. Because the Moon has no appreciable atmosphere, there is no ambient occlusion or scattering of sunlight. Lunar shadows are pitch black, and you should alter the black point of your image to reflect this, whilst drawing the highlights up. By adjusting image gamma, you can draw out an unnaturally high contrast result, which gives a very interesting view of the subtle shading in the maria. You may also wish to crop and rotate or flip your image to compensate for the lenses and mirrors in your telescope. You can use the map on page 25 to see

Stacking in process.

Left: a single subframe. Right: the stacked image.

RegiStax main window.

The stacked image imported into RegiStax with the Wavelet tab selected.

Applying wavelet deconvolution to a portion of the image.

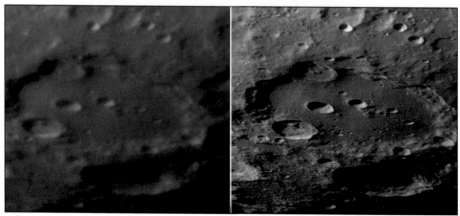

Left: the stacked image before deconvolution. Right: the final image after deconvolution and further contrast adjustment in Photoshop.

the Moon in its 'correct' orientation as viewed from the northern hemisphere. With your adjustments made you are ready to export your image in a format suitable for sharing, and to show off to your friends and colleagues! Just remember to keep all your data. As you practise this workflow over and over, you'll become better at getting the most out of your image sequences. One day you'll be able to revisit your old data and produce a better result with your hard-earned processing skills.

Creating Videos from DSLR Images

In order to stack subframes from a DSLR, we must first sequence them and contain them in a video file. The free software PIPP (Planetary Image Pre-Processor) can join raw image files and produce an uncompressed video.

Drag your collection of files on the PIPP window and the software will notify you that join mode has been selected. From there, go to the Output Options tab and ensure the Output Format is set to AVI or SER. Go to the Do Processing tab and click Start Processing. Your resultant video file is now ready to be used for stage 1 of this guide.

PIPP can stabilise frames, centring the Moon in each image, and this may be useful if your photos are not very consistent. The options are found under the Processing Options tab.

Revealing the Moon's True Colours

It's fitting that at the end of this book, we'll return to its front cover, and explore a method of producing unreal, prismatic photos of the Moon, revealing its mineral variance. To our eyes, the Moon can take on many hues, usually due to scattering of light in the Earth's atmosphere. When the Moon is rising or setting, its image is reddened as the light passes through a relatively dense

slice of air, in the same manner as the Sun. If the Moon passes through the Earth's shadow – a lunar eclipse – it can take on a deep red colour, but in this case, the scattering occurs before the sunlight reaches the lunar surface, and so the Moon really is red.

However, in most ordinary circumstances, we perceive the Moon's surface as showing varying shades of grey, but we don't have the luxury of storing and postprocessing our visual memories to enhance its true, if very subtle, colours. As we have seen, raw photos have a very high colour depth, and high-SNR images can be enhanced to an extreme degree. Because DSLR cameras record colour information with high accuracy, we can employ both of these concepts using either a collection of stacked subframes or a single, sharp and low-noise photo.

In this example, 25 photos were taken in quick succession using a DSLR and small telescope, with a focal length of about one metre. They were then stacked using AutoStakkert! to produce a high-SNR image, which was lightly sharpened using the Wavelets feature in RegiStax.

The resultant image shows Mare Tranquillitatis (the Sea of Tranquility) with a subtle, dark blue shade. Our eyes alone would usually struggle to pick this up, even with a telescope, but the camera data is already hinting at a great deal of unseen colour to be drawn out. At each step, take care to ensure you are exporting your images in 16-bit colour, so as not to lose any valuable data.

Adobe Photoshop and some of its competitors have two controls for adjusting the apparent strength of the colour called Saturation and Vibrance. Usually a good image requires a boost to both, and these can be set up as adjustment layers, allowing you to easily hide them or switch between them, until you achieve the aesthetic you

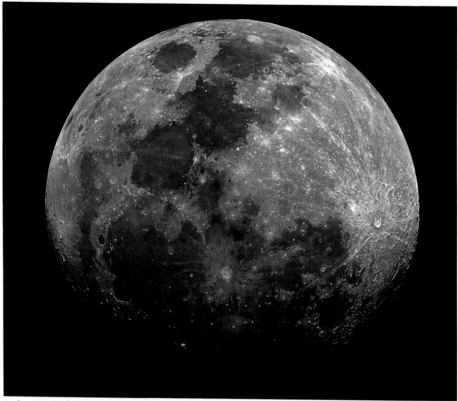

A photograph of the Moon with normal saturation.

like best. Try to avoid the temptation of overdoing it, as it's possible to introduce too much colour, or exacerbate the false colour often present in telescope optics. The predominant colours you reveal should be blue and orange or yellow. We've seen the blue in the lunar maria already, but the other shades are harder to pick out. After **playing** with the saturation and vibrance, you can readily achieve a striking result, with far more colour on display.

Suddenly, our familiar satellite has a whole new personality! Many of the flat volcanic plains are a pronounced blue colour like Mare Tranquilitatis, whereas rugged lunar highlands have a distinctive rusty appearance.

Realising that this colour has always been present, albeit unseen, is one thing, and producing your own beautiful photo is another. But there's a third facet to this exercise. Astronomers have been studying these colours for decades, and recently NASA's Lunar Reconnaissance Orbiter – one of the most advanced satellites ever sent to the Moon – has produced a global colour map of the surface, a small section of which is seen on page 88 in comparison to our ground-based image, confirming that the colours we see are real.

These colours have great scientific value, offering clues as to the mineral composition of the lunar surface. The obvious blue tones are produced when sunlight is reflected off basalts containing

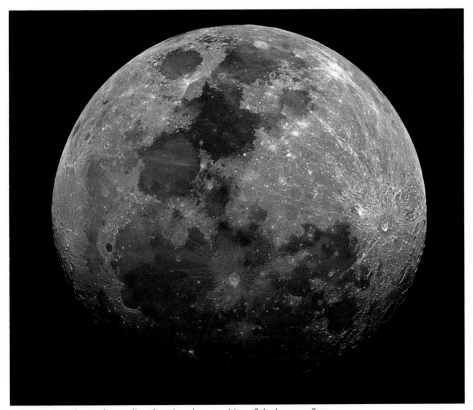

Extreme saturation push revealing the mineral composition of the lunar surface.

relatively high concentrations (over 7 per cent by weight) of titanium dioxide ($TiO2$). We've seen that a 'Blue Moon' doesn't look the way its name suggests, but it turns out large areas of the lunar surface really are blue. The yellow or orange hues are a combination of terrestrial-type basalts (where the titanium dioxide concentration is less than 2 per cent by weight) and a relatively high abundance of a more familiar oxide, iron oxide (FeO), also known as rust. High concentrations of iron oxide and titanium dioxide render the maria darker than the highlands, due to their relatively low reflectivity. The rugged older highlands with their numerous impact craters have a broadly ferrous appearance, with brighter near-white streaks where relatively fresh material from more recent impacts has settled on top of the darker rock below.

The cover of this book takes the high-colour lunar photography method to its limit. A mosaic of black and white, high resolution images – taken at high magnification with a dedicated astronomy camera – has been combined with the colour information from a burst of DSLR images. With the colour image as the top layer, set its blending mode to 'Colour' and manually rescale and position it over your sharp, monochrome bottom layer. Just ensure that you collect all the images on the same night, so the Moon's libration is consistent. In this way, you can find a combination of fine detail and vivid colour that is most complementary to produce an aesthetically interesting result. Good luck and clear skies!

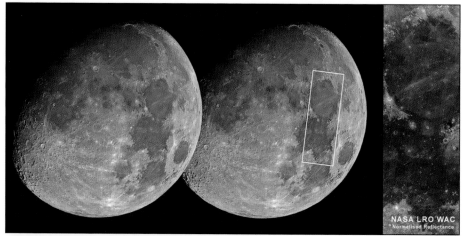

A comparison of a ground-based image with the NASA Lunar Reconnaissance Orbiter's precise measurements of colours.

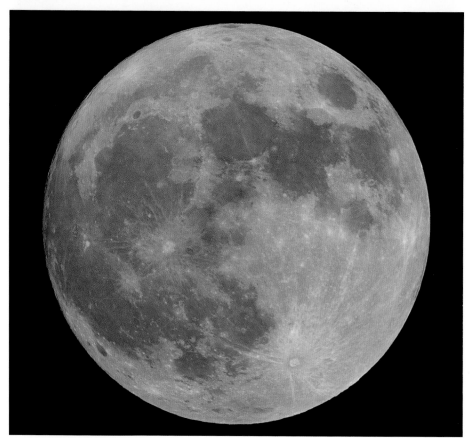

A gently oversaturated Full Moon.

Glossary of Terms

Apparent angle	The angle subtended by an object in the sky – measured in degrees, minutes and seconds – as it appears from the surface of the Earth.
Apparent lunar diameter	The diameter of the Moon, measured from west to east across its centre, as seen from the surface of the Earth. Given in units of arcminutes and arcseconds, the Moon's apparent diameter can take values between 29'20" and 34'6" depending on its location in its orbit.
Arcsecond	Equal to 1/60th of an arcminute and 1/3,600th of a degree, an arcsecond (or second of arc) denoted " is a unit of size or separation on the celestial sphere. Objects are said to subtend X arcseconds or be Y arcseconds apart.
Atmospheric drag	A force acting on bodies travelling through an atmosphere, produced by collisions with gas atoms. Drag reduces the speed of orbiting bodies, ultimately causing them to fall.
Day side	The side of a celestial body illuminated by the Sun.
Declination	Equivalent to latitude on Earth – how far north or south an object is on the celestial sphere. Measured in degrees with the celestial equator at 0°
Exposure time	Measured in seconds – the length of time a camera's shutter is left open. Longer exposure times are used to collect more light for a brighter photograph.
Gravitational bond	The force between two celestial bodies, which prevents them from drifting apart. The Earth and Moon are gravitationally bound together.
Libration	An apparent 'wobbling' of the Moon, allowing us to peer around its eastern or western limb to observe a total of about 59 per cent of its surface. Libration occurs as the Moon changes speed in its non-circular orbit, but continues to rotate on its own axis at a fixed rate.
Lunar apogee	The point in the Moon's orbit where the centre of the Moon and the centre of the Earth are farthest apart.
Lunar perigee	The point in the Moon's orbit where the centre of the Moon and the centre of the Earth are closest together.
Lunar synodic month	The period of the cycle of lunar phases, measure from full moon to full moon, equal to 29.5 solar days.
Night side	The side of a celestial body not illuminated by the Sun.

Precession	A gradual change in the orientation of the rotational axis of a celestial body. The Earth's axis rotation traces a circle due to precession once every 25,772 years.
Precession of the line of apsides	The slow rotation of the line connecting lunar perigee and lunar apogee (the line of apsides), as the Moon's orbit itself rotates around the Earth once every 8.88 years.
Regolith	A fine, powdery material covering the surface of the Moon, made primarily of oxygen, silicon and iron.
Right ascension	Equivalent to longitude on the celestial sphere, right ascension (measured in hours, minutes and seconds) describes the position of an object in the sky relative to a fixed point known as the First Point of Aries.
Seeing	A measure of the effect of atmospheric turbulence on the steadiness of the appearance of the stars and other objects. Steady conditions are described as good seeing.
Seismometer	A device for measuring seismic activity – vibrations in the crust of the Earth or Moon. Seismometers measure the strength of earthquakes and moonquakes, offering insights into the internal structure.
Sidereal day	The period of Earth's rotation measured against the fixed stars. A mean sidereal day is 23 hours, 56 minutes and 4.09 seconds long.
Sidereal month	The period of one sidereal lunar orbit, equal to 27.3 solar days.
Sidereal orbit	An orbit as measured with respect to a fixed position on the celestial sphere.
Solar day	The period of Earth's rotation measured against the Sun. A mean solar day is 24 hours long.

Software References

FireCapture by Torsten Edelmann
(WIN/MAC/LINUX)
www.firecapture.de

Free software for capturing video sequences with webcams or dedicated high-framerate astronomy cameras. Mac and Linux support are limited to QHY and ZWO cameras at the time of writing.

AutoStakkert! by Emil Kraaikamp (WIN)
www.autostakkert.com

Free image alignment and calibration software, which includes support for H264 videos (from DSLR cameras) as well as sequences from dedicated astronomy cameras.

RegiStax by Cor Berrevoets (WIN)
www.astronomie.be/registax

Free calibration and deconvolution software, recommended for applying wavelet calculations to high signal-to-noise ratio images.

GIMP – GNU Image Manipulation Program
(WIN/MAC/LINUX)
www.gimp.org

Free, cross-platform image processing application with support for 16-bit files. GIMP has many features and is under constant development.

Adobe Photoshop CC (WIN/MAC)
www.adobe.com/photoshop

Comprehensive image editing software offered as part of a subscription to Creative Cloud with various pricing models. Photoshop currently offers the best tools for manipulating colour in images.

Lunar and solar eclipses:

Eclipse information was historically published by the Royal Observatory Greenwich in their annual edition of the Nautical Almanac. Today, this tradition continues, with information now available from Her Majesty's Nautical Almanac Office, a department of the UK Hydrographical Office, and the US Naval Observatory. To find an upcoming eclipse, visit: http://astro.ukho.gov.uk/eclipse/ or go to http://eclipse.gsfc.nasa.gov/eclipse.html

OBSERVING LOG

Date:.................. Seeing:................. Transparency:.................

Region or feature:.................

Moon age:

Focal length:

Eyepiece:

Magnification:

Notes:

.................

.................

.................

.................

.................

.................

Date:............................ Seeing:............................ Transparency:............................

Region or feature:............................

Moon age:

Focal length:

Eyepiece:

Magnification:

Notes:

............................

............................

............................

............................

............................

Lunar Index

Acknowledgments

4, 5	© Tom Kerss
6 top	Kelvinsong CC by 3.0
6 bottom	© Tom Kerss
7	© Tom Kerss
8 top	NASA/Goddard/Arizona State University
8 bottom	© HarperCollins Publishers, Earth: Antony McAuley/Shutterstock Moon: Koryaba/Shutterstock
9	© HarperCollins Publishers, Earth: Antony McAuley/Shutterstock Moon: Koryaba/Shutterstock
10	© HarperCollins Publishers, Sun: xfox01/Shutterstock Earth: Antony McAuley/Shutterstock Moon: Koryaba/Shutterstock
11	© HarperCollins Publishers, Sun: xfox01/Shutterstock Earth: Antony McAuley/Shutterstock Moon:Koryaba/Shutterstock Moon phases: Lick Observatory
12–13	NASA/GSFC/Arizona State University
14–15	NASA/LRO
16-19	Image: NASA/GSFC/Arizona State University, maps Collins Bartholomew Ltd
20	Donald A. Mackenzie, *Myths of Babylonia and Assyria* (1915), p. 50 [1][2], Messrs. Mansell & Co.
21 top left	© MAX ALEXANDER/LORD EGREMONT/SCIENCE PHOTO LIBRARY
21 bottom left	Galileo Galilei Apud Thomam Baglionum, *Sidereus Nuncius* 1610. Courtesy of the Smithsonian Libraries https://www.library.si.edu/digital-library/book/sidereusnuncius00gali
21 top right	© Historic Images/Alamy Stock Photo
22 top left	NASA
22 bottom left	NASA/JPL
22 right	NASA
23	NASA
24 left	NASA/GSFC/Arizona State University
24 top right	NASA
24 middle right	NASA/Eugene Cernan
24 bottom right	NASA
25	NASA/GSFC/Arizona State University
26	NASA/ESA/T. Lombry
27 top	© Tom Kerss
27 bottom	© HarperCollins Publishers Moon: Koryaba/Shuterstock Hand with coin: Hein Nouwens/Shutterstock face: Skitale/Shutterstock Small coin: AlexanderZam/Shutterstock
28 top left	photoHare/Shutterstock
28 bottom left	Kapege.de/CC by SA-2.5
28 right	Trikona/Shutterstock
30	© National Maritime Museum, Greenwich, London.
31 top	© HarperCollins Publishers, Sun: xfox01/Shutterstock Earth: Antony McAuley/Shutterstock Moon: Koryaba/Shutterstock
31 bottom left	Solar eclipse from Orkney, March 2015, © Mark Ferguson
31 bottom right	The Diamond Ring, © Melanie Thorne
32	Tuanna2010:CC by 3.0
33, 34, 35	© Tom Kerss
36–67	NASA/GSFC/Arizona State University
68, 69, 70, 71, 72, 73	© Tom Kerss
74 left	© Tom Kerss
74 right	celestron.com
75	Anthony Guiller E. Urbano (www.nightskyinfocus.com)
76 top	© Tom Kerss
76 bottom	With kind permission of the ZWO Company https://astronomy-imaging-camera.com/
77 top	With kind permission of The Imaging Source http://www.astronomycameras.com/
77 bottom	With kind permission of Farpointastro.com
78 top	With kind permission of Levenhuk.com
78 bottom	©Astronomik/Eric-Sven Vesting https://www.astronomik.com/
79, 80, 81, 83, 84, 86, 87	© Tom Kerss
88 top	© Tom Kerss /NASA/LRO
88 bottom	© Tom Kerss